WHALES & DOLPHINS

John Birdsall

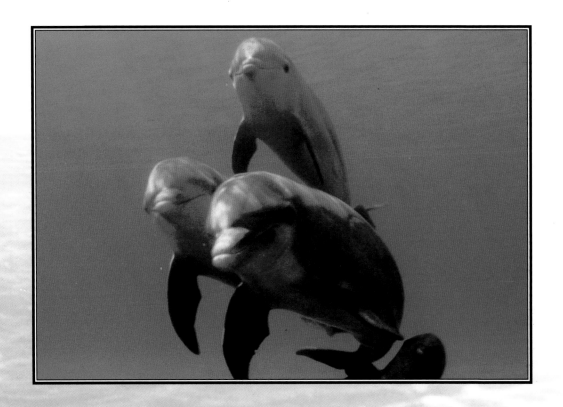

SIENA

This is a Siena book
Siena is an imprint of Parragon

Parragon
13 Whiteladies Road
Clifton
Bristol BS8 1PB

ISBN: 0-75252-632-4

Conceived, designed and produced by Haldane Mason, London

Acknowledgements
Art Director: Ron Samuels
Editor: Charles Dixon-Spain
Designer: Zoë Mellors
Picture Researchers: Jackum Brown/Charles Dixon-Spain
Indexer: Conan Nicholas

Colour reproduction by
Regent Publishing Services, Hong Kong

Printed in Italy

Picture Acknowledgements
B. & C. Alexander 7, 90, 91, 92, 93; **Ardea** © François Gohier 4–5, 10–11, 14, 22, 26, 34, 37, 42, 51, 64, 70, 73/© Mike Osmond & Auscape 49/© Kenneth W. Fink 82 (top); **Peter Arnold, Inc.** © Dr Harvey Barnett 76; **BBC** © Jeff Foott 54, 74 (bttm); **Bruce Coleman** 1/© Erwin & Peggy Bauer 6, 19/©Jeff Foott 16/© Johnny Johnson 36/© Mark Cawardine 41/© G. Zeisler 52/© Ken Balcomb 77/© Rinie Van Meurs 78–9/© Guido Cozzi 94; **NHPA** 12, 24, 67, 69/© Gerard Lacz 33/© Norbert Wu 35/© Kevin Schafer 56–7/© Rich Kirchener 84; **Oxford Scientific Films** © Howard Hall 13, 83/© George K. Bryce 17/© Gregory Ochocki 32/© Kim Westerkov 38–39/© David B. Fleetham 44/© Tony Martin 55/© Clive Bromhall 85 (top)/© Tui de Roi 86; **Planet Earth Pictures** 28, 31, /© James D. Watt 23, 50, 60, 80, 88–9/© David Rootes 25/© Pete Atkinson 32, 62/© Marty Snyderman 40, 95/© Doug Perrin 47, 59, 61, 63, 74 (top), 75, 81/© Pieter Folkens 82 (bttm); **Still Life Pictures** © Mark Cawardine 20–1, 46/© Louise Murray 1, 43, 85; **World Wildlife Fund** 15

Every effort has been made to trace the copyright holders and we apologize in advance for any unintentional errors or omissions. We would be pleased to insert the appropriate acknowledgement in any subsequent edition of this publication.

Page 1: Bottlenose dolphins are active predators.
Their forward-facing eyes allow them to judge
distance – at least at close range – when hunting.

C O N T E N T S

Introduction

'Leviathan. . .

Upon earth there is not his like,

who is made without fear.'

Job, *1: 1, 33*

The fast swimming and athletic Atlantic spotted dolphin typifies
the grace and beauty of cetaceans that has captivated humanity
for centuries.

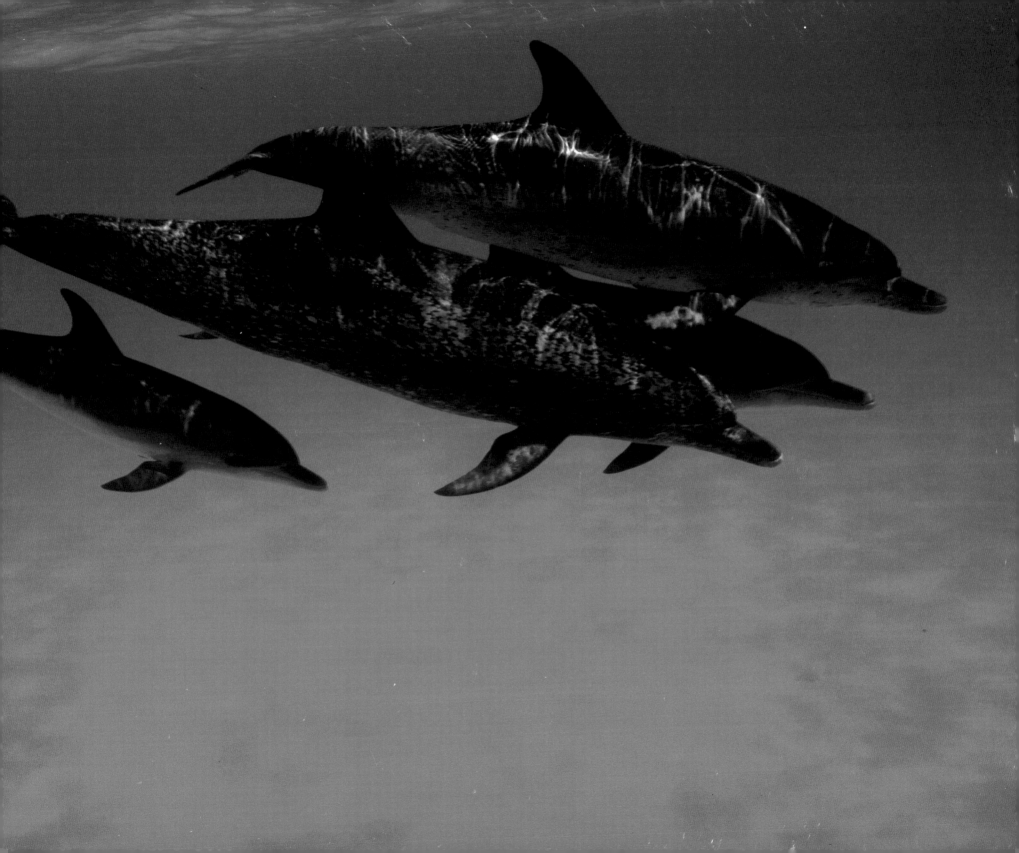

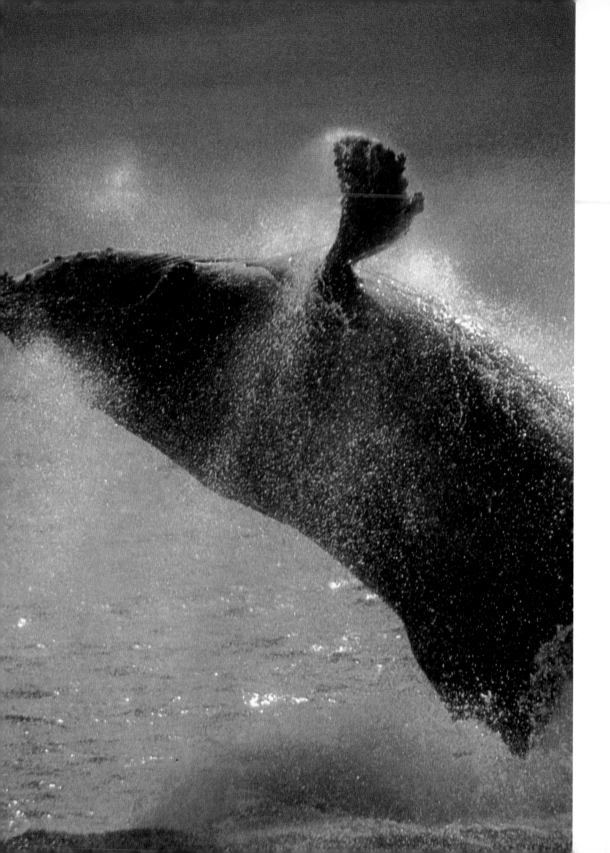

From space it is easy to see why our world is also known as the 'Blue Planet'. With over 70 per cent of its surface covered by oceans and seas, it is water, not land, that is the globe's dominant element. Yet it is no accident that we call our planet 'Earth', for we are terrestrial creatures, evolved for life on dry land. It is also no surprise that we should feel most empathy with animals that share our terrestrial base. Many, such as the lion, tiger and polar bear, we respect and revere for their prowess as powerful predators. To others, like the wolf and small cat, we have felt such kinship that we have even brought them into our homes and made them our domestic friends.

But crashing noisily on the shores of our dry domain there has always been a greater, more mysterious and secret world – the vast watery kingdom of Neptune. Humans have always viewed this world with both fear and fascination. Poorly equipped even to journey on its unpredictable surface, only relatively recently have we been able to explore its hidden depths. Encased in pressurized suits or encapsulated in strange-looking craft, our investigation of the oceans has not been unlike our exploration of space. In this alien world we have found much to intrigue us – and many resources to exploit. But, not surprisingly, perhaps, we have found little in the way of kinship with the strange creatures we have encountered. Among the denizens of the deep, only the cetaceans – whales and dolphins – have evoked in us the kind of awe, respect and affection we normally reserve for our furred and feathered friends on land.

Our special relationship with these fascinating creatures has a long history. Just as the cave paintings of Lascaux, France, bear witness to Stone Age peoples' preoccupation with mammoth and deer, so 4000-year-old rock carvings at Skegerveien, Norway, indicate that whales were also highly esteemed. And while these images were almost certainly related to the whales' importance as a food source, in the almost equally old frescoes at Knossos, Crete, the Minoans paid artistic tribute to dolphins in homage to their grace and beauty.

As hunters, early humans would have had an intensely personal relationship with whales and dolphins. But in more recent times our relationship with these aquatic creatures has been far more detached and increasingly exploitative. A vast industry grew up solely to catch, kill and process the giants of the deep to keep a fast developing world supplied with, among other things, oil to lubricate its machines. As the whalers grew ever more efficient, however, the numbers of their quarry fell, and during the eighteenth and nineteenth centuries the industry went from boom to bust several times. Determined to plunder whale stocks to the full, the whalers responded with faster ships and more deadly harpoons. By the 1970s, the future of all the large species of whale was looking grim and conservationists began to raise public awareness of their plight.

'Save the Whale' became a clarion call to all those keen to re-establish a more sympathetic and harmonious relationship with nature. Despite the fact that few people had ever even seen a whale, these creatures became a symbol of a new attitude to the other creatures with which we share our planet. If we could wipe out these ocean giants so carelessly, what future would there be for any of the world's wildlife?

Opposite: An exuberant humpback breaches - launching its 30-tonne bulk clear of the water. Such displays provide brief glimpses of the often complex behaviour of these enigmatic marine mammals.

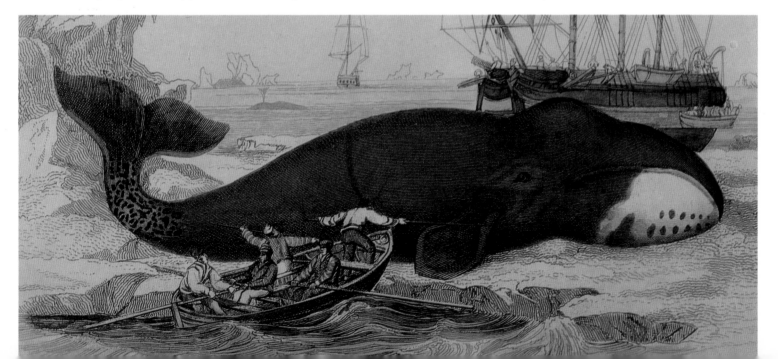

By the nineteenth century, whaling had become a lethally efficient - if dangerous - industry, and many northern populations of bowhead and right whales were seriously depleted.

It was evident that, despite hunting these creatures to the very brink of extinction, we actually knew very little about them. And with every little we learned there grew an even greater desire to know more. Yet the very mystery that surrounds these leviathans somehow galvanized a concerned public, and interest in whales rose markedly. 'Save the Whale' may have been one of the least focused conservation slogans ever devised – for there are nearly 80 species of whale, and no species was singled out – but it neatly summed up the collective feeling for all these creatures and helped to give the campaign a broader appeal than that achieved by any directed towards a single species, like the giant panda.

Whales are the largest creatures ever to have lived on Earth, they have large, complex brains, and many are highly social and show a loyalty to each other that is remarkable. Many of the smaller species, such as the dolphins, also seem to possess an irresistible curiosity and demonstrate a sense of fun that is easy for humans to relate to. Furthermore, the eventual, widespread recognition that whales and dolphins are actually mammals, like us, made the barbarous way in which they were being killed seem totally unacceptable.

In a changing world, the future of whales and dolphins is still far from certain, but the growing interest in studying, rather than hunting, them is an encouraging sign. The more we can learn about these remarkable and enigmatic creatures, and the better we back up their needs by positive action, the greater chance they will have of a secure future.

ORDER: CE

SUBORDER – Baleen Whales
Mysticeti

FAMILY – Right Whales
Balaenidae

- Bowhead whale
 Balaena mysticetus
- Southern right whale
 Eubalaena australis
- Northern right whale
 Eubalaena glacialis

FAMILY – Pygmy right whales
Neobalaenidae

- Pygmy right whale
 Capera marginata

FAMILY – Grey whale
Eschrichtiidae

- Grey whale
 Eschrichtius robustus

FAMILY – Rorqual whales
Balaenopteridae

- Minke whale
 Balaenoptera acutorostra
- Sei whale
 Balaenoptera borealis
- Bryde's whale
 Balaenoptera edeni
- Blue whale
 Balaenoptera musculus
- Fin whale
 Balaenoptera physalis
- Humpback whale
 Megaptera novaeangliae

CEA WHALES & DOLPHINS

SUBORDER – Toothed Whales
Odontoceti

FAMILY – Beaked whales
Ziphiidae

- Arnoux's beaked whale
 Berardius arnuxi
- Baird's beaked whale
 Berardius bairdii
- Northern bottlenose whale
 Hyperoodon ampullatus
- Southern bottlenose whale
 Hyperoodon planifrons
- Indo-Pacific beaked whale
 Indopacetus pacificus
- Sowerby's beaked whale
 Mesoplodon bidens
- Andrew's beaked whale
 Mesoplodon bowdoini
- Hubbs' beaked whale
 Mesoplodon carihubbsi
- Blainville's beaked whale
 Mesoplodon densirostris
- Gervais's beaked whale
 Mesoplodon europaeus
- Ginko toothed beaked whale
 Mesoplodon ginkodens
- Gray's beaked whale
 Mesoplodon grayi
- Hector's beaked whale
 Mesoplodon hectori
- Strap-toothed beaked whale
 Mesoplodon layardi
- True's beaked whale
 Mesoplodon mirus
- Lesser beaked whale
 Mesoplodon peruvianus
- Stejnegeri's beaked whale
 Mesoplodon stejnegeri
- Shepherd's beaked whale
 Tasmacetus shepherdi
- Cuvier's beaked whale
 Ziphius cavirostris

FAMILY – River dolphins
Plantistidae

- Amazon river dolphin
 Inia geoffrensis
- Yangtze river dolphin
 Lipotes vexillifer
- Ganges river dolphin
 Platanista gangetica
- Indus river dolphin
 Platanista minor
- La Platta river dolphin
 Pontoporia blainvillei

FAMILY – Narwhal & Beluga
Mondontidae

- Beluga
 Delphinapterus leucas
- Narwhal
 Monodon monoceros

FAMILY – Sperm whales
Physeteridae

- Pygmy sperm whale
 Kogia breviceps
- Dwarf sperm whale
 Kogia simus
- Great sperm whale
 Physeter macrocephalus

FAMILY – Porpoises
Phocoenidae

- Spectacled porpoise
 Phocoena dioptrica
- Finless porpoise
 Neophocaena phocaenoides
- Common porpoise
 Phocoena phocoena
- Vaquita
 Phocoena sinus
- Burmeister's porpoise
 Phocoena spinipinnis
- Dall's porpoise
 Phocoenoides dalli

FAMILY – Oceanic dolphins
Delphinidae

- Commerson's dolphin
 Cephalorhynchus commersonii
- Black dolphin
 Cephalorhynchus eutropia
- Heaviside's dolphin
 Cephalorhynchus heavisidii
- Hector's dolphin
 Cephalorhynchus hectori
- Common dolphin
 Delphinus delphis
- Pygmy killer whale
 Feresa attenuata
- Shortfinned pilot whale
 Globicephala macrorhynchus
- Longfinned pilot whale
 Globicephala melaena
- Risso's dolphin
 Grampus griseus
- Fraser's dolphin
 Lagenorhynchus hosei
- Atlantic white-sided dolphin
 Lagenorhynchus acutus
- White-beaked dolphin
 Lagenorhynchus albirostris
- Peale's dolphin
 Lagenorhynchus australis
- Hour-glass dolphin
 Lagenorhynchus cruciger
- Pacific white-sided dolphin
 Lagenorhynchus obliquidens
- Dusky dolphin
 Lagenorhynchus obscurus

- Northern right whale dolphin
 Lissodelphis borealis
- Southern right whale dolphin
 Lissodelphis peronii
- Irrawaddy dolphin
 Orcaella brevirostris
- Killer whale
 Orcinus orca
- Melonhead whale
 Peponocephala electra
- False killer whale
 Pseudorca crassidens
- Tucuxi
 Sotalia fluviatilis
- Indopacific humpbacked dolphin
 Sousa chinensis
- Atlantic humpbacked dolphin
 Sousa teuszii
- Pantropical spotted dolphin
 Stenella attenuata
- Clymene dolphin
 Stenella cymene
- Striped dolphin
 Stenella coeruleoalba
- Atlantic spotted dolphin
 Stenella frontalis
- Long-snouted dolphin
 Stenella longirostris
- Rough-toothed dolphin
 Steno bredanensis
- Bottlenose dolphin
 Tursiops truncatus

The Whale's Tale

'That sea beast
Leviathan, which God of all his works
Created hugest that swim the ocean
stream.'

Milton, *Paradise Lost*

With a final flick of its flukes, a humpback disappears beneath
the surface....

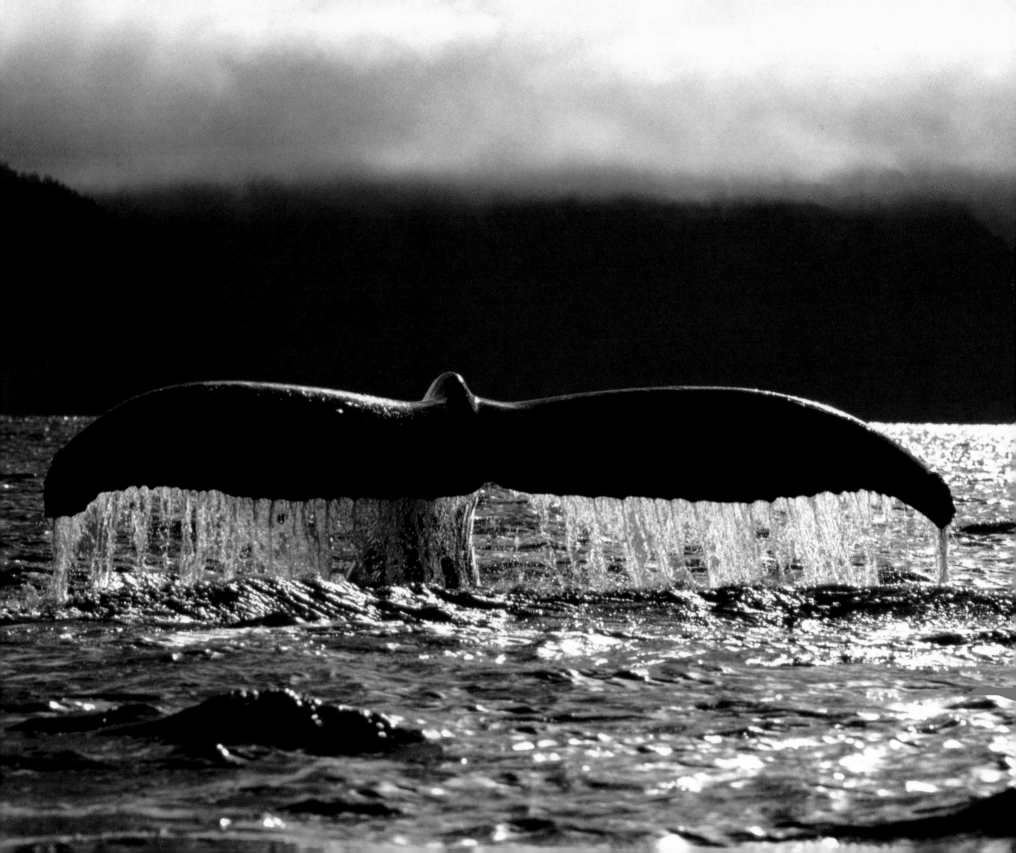

Opposite: Belugas - or white whales - currently inhabit icy northern polar seas, but 10-12 million years ago they swam in the warmer waters off California and Mexico. Although superficially similar to many other small cetaceans, they appear to be most closely related to dolphins and porpoises.

Whales and dolphins are mysterious, elusive creatures that spend most of their lives underwater, often far out in the trackless oceans. Infrequently seen and difficult to study, it is perhaps not surprising that these marvellous animals were, for many years, known as 'spouting fish'. But despite their physical similarities to large predatory fish such as sharks, whales are, in fact, mammals. They are warm-blooded, air-breathing animals that give birth to live young that are suckled on milk by their mothers. Their superficial similarity to many of the other creatures with which they share their watery habitat is simply due to convergent evolution – in other words, whales resemble fish simply because they have adapted to a very similar way of life in the same habitat.

Although experts disagree on the exact number, there are thought to be about 80 different species

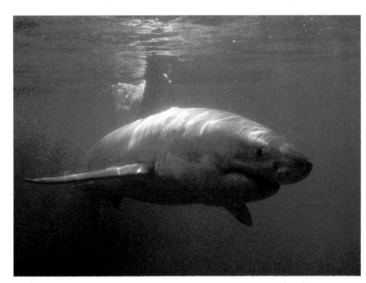

The superficial similarity between many cetaceans and sharks, such as the great white, is a product of convergent evolution, whereby two quite unrelated groups of animal have developed many of the same external adaptations to life in water.

of whale and dolphin. Together, these species are placed in the order Cetacea and are known collectively as cetaceans, from the Latin *cetus* meaning a large sea animal and the Greek *ketos* meaning sea monster.

Although it is likely that all life on Earth first began in the sea, cetaceans, unlike their fishy relatives, are evolved from animals that, for a time, forsook the water for life on dry land. Cetaceans are not the only mammals to have developed in this way. Today there are two other major mammal groups that after a period of development on land, many millions of years ago, returned to the sea. The least aquatic of these are the seals, sealions and walrus, which are placed together in the order Pinnipedia. Pinnipeds are amphibious rather than aquatic animals, for although they spend much of their lives in the water they have also retained the ability – and need – to haul themselves out on to the land. Most pinnipeds are also covered in dense hair that acts as insulation against the often icy waters they inhabit, as well as providing protection from abrasion on rocks when they come ashore. By contrast, the second group of sea mammals, the Sirenia, which includes the dugong and manatees, are purely aquatic. Sirenians live in shallow, warm, coastal waters or rivers where they graze the abundant underwater vegetation – a habit that gives them their aptly descriptive common name: sea cows. But of these three groups it is the cetaceans that have most completely reverted to life in the seas and oceans of our blue planet.

Cetacean evolution

Tracing the evolutionary history of any species or group of species requires a fascinating amount of detective work, not unlike uncovering the perpetrator of some long-forgotten crime. All trails are cold and the witnesses long dead – but for the sharp-eyed and diligent detective there are plenty of clues to be uncovered. Chief among these are the fossils of creatures now extinct that can be physically pieced together to create a picture of how these kinds of animal developed over time. To the fossil record can be added the genetic information of living species. Careful comparison of the DNA in the cells of living species not only indicates how closely or distantly related two particular species are, it can also indicate an approximate date at which they diverged from a common ancestor.

Despite the intensive research of many hundreds of 'time detectives', the exact origins of modern cetaceans remain shrouded in mystery. Using such information as there is, it is generally agreed that modern day whales and dolphins developed from predatory land mammals about 70 million years ago. More open to debate is the exact nature of these animals. Some experts believe that they were medium-sized, large-headed mammals known as Creodonts – animals that may have developed into the carnivores and hoofed mammals of today.

Exactly where this process took place is open to argument, but judging by the fossil record it is most likely that it occurred around the ancient Tethys Sea in a region that is now occupied by the Mediterranean and

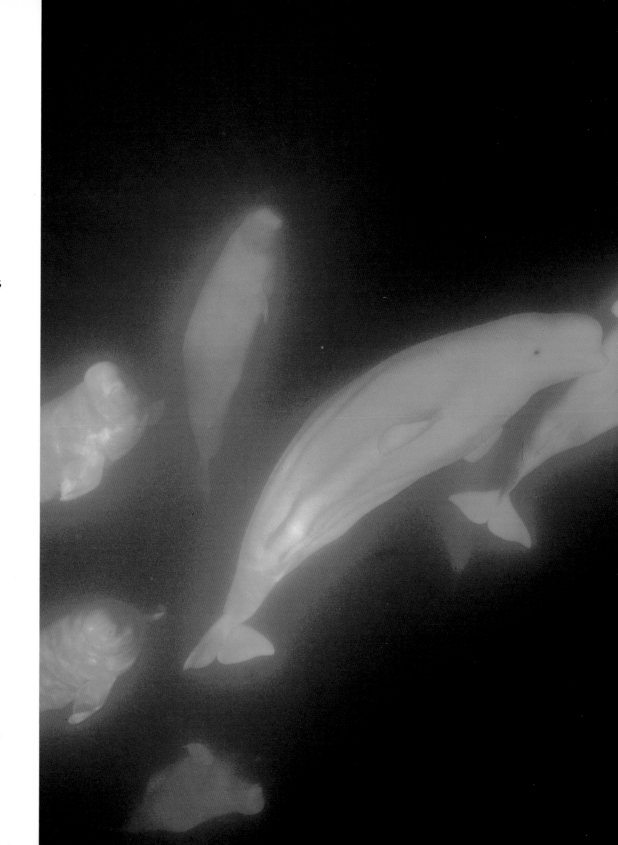

Below and opposite:
The grey whale is in many ways so different from other baleen whales that it has probably been evolving in isolation for many millions of years. The oldest fossils of this whale so far found, however, are only about 100,000 years old and are almost indistinguishable from living grey whales.

parts of Asia. In what were probably salty river estuaries, the ancestors of the whales took their first experimental steps towards an aquatic way of life. For many millions of years, however, these aquatic mammals would have borne scant resemblance to the sleek leviathans we know today. Instead, they would have been far less 'seaworthy' and almost certainly retained the four quite distinct limbs that served them previously on land. Although there is no hard evidence, it is probable that these creatures were about as aquatic as modern hippos, and that their diet was chiefly made up of molluscs and crustaceans that

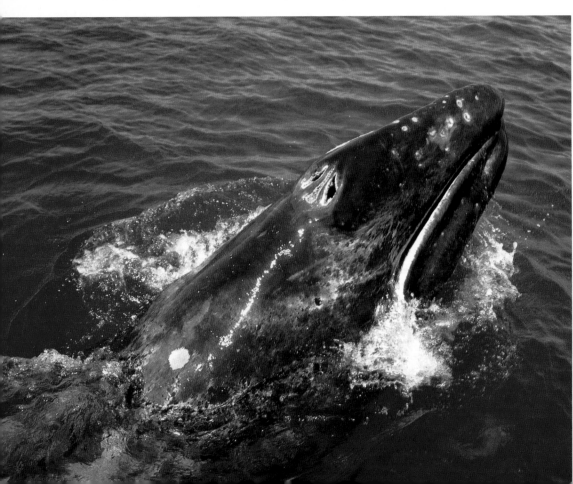

they collected from the river bed, supplemented by whatever fish they were lucky enough to catch.

In the swim

To paraphrase the father of modern biology, Charles Darwin, animals evolve by a process of natural selection in response to a changing environment. And in the case of these ancient aquatic mammals, the new environment to which they had to adapt most rapidly was that of water. This required such fundamental change that, externally at least, no part of the cetacean's body was left untransformed. Most obvious of all of these changes was the development of a torpedo-shaped body that would slip easily through the water. A new means of propulsion also had to be found: while the early cetaceans could no doubt have paddled their way through the relatively calm estuaries they first inhabited, using their limbs in much the same way as a dog, this method would have been both inefficient and expensive in terms of energy. Over time, therefore, their hindlimbs were replaced by a powerful blade-like tail, supported by massive muscles, while their forelimbs evolved into slim fins for controlling direction. For stability a dorsal fin was also developed – although in some species this was subsequently lost. The end result was a remarkably fish-like form, but with certain clear differences. Cetaceans, for example drive themselves through the water with up-and-down strokes of their tails. Fish, on the other hand, move more sinuously, sweeping their tails sideways through the water.

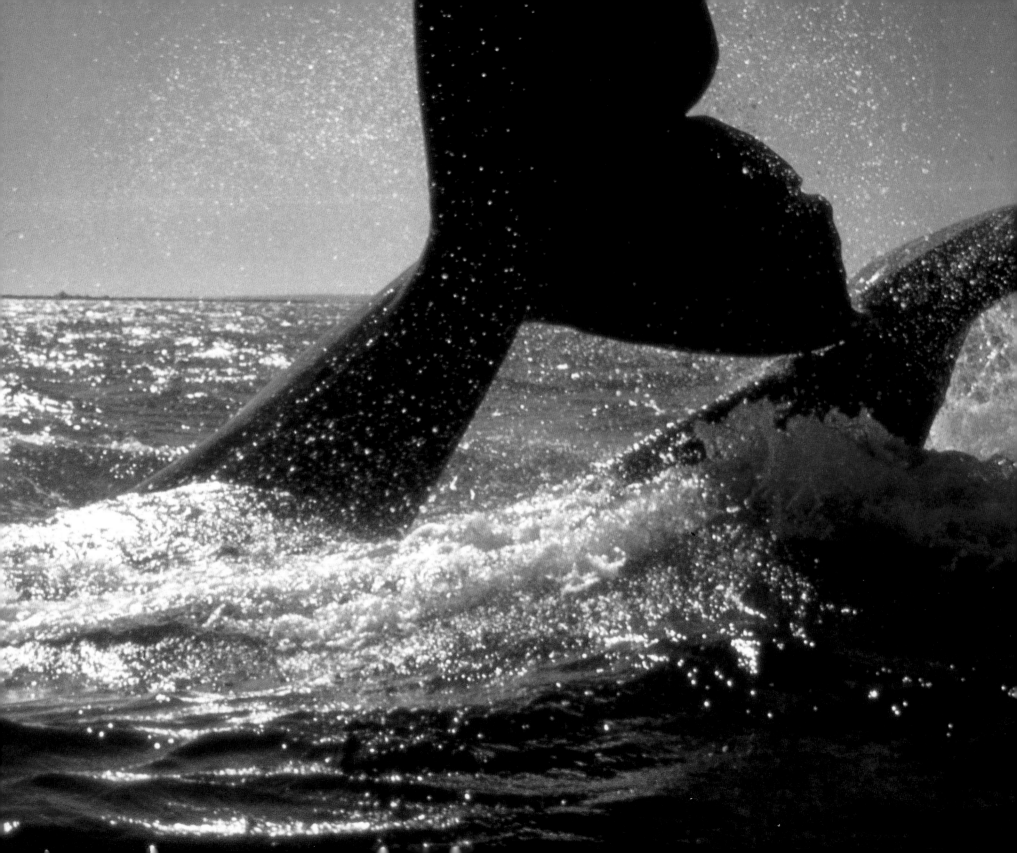

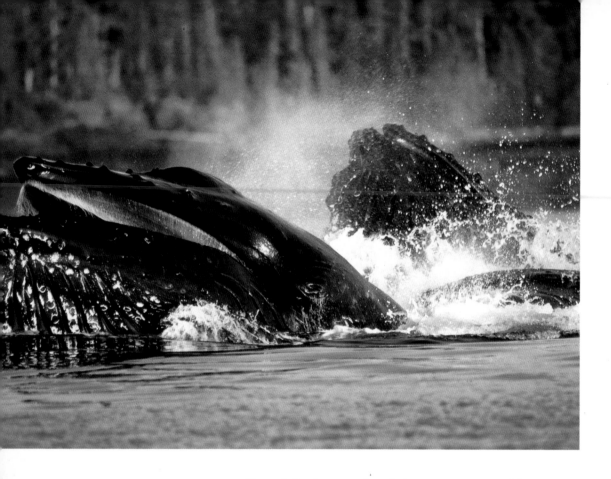

About 30 million years ago, the first baleen whales began to appear. These whales exploited the seas' rich harvest of zooplankton by sieving it from the water. To do this they developed plates of baleen, made of a skin-like material called keratin, which eventually replaced their teeth. Today there are 11 species of baleen whale including the humpback whale.

But while these early whales came to resemble many of the fish with which they shared their new home, in some areas of their development they could not shake off their land-bound ancestry. The most obvious of these is the cetacean's need to breathe air. To facilitate the process in water, however, the nostrils migrated from the end of the muzzle to the top of the head, allowing the whale to inhale and exhale at the surface. But no mammal species developed the ability of fish to extract oxygen directly from the water using gills.

As well as a new body plan, the early cetaceans also had to modify their senses – and develop new ones – to find prey, and each other, in the often dark or murky waters of their new habitat. Their eyes changed so that they could see in water as well as air, while their ability to produce and detect sound, which travels more efficiently in the denser medium of water, became far more important.

In response to their new marine diet, the teeth of the early cetaceans also changed. Instead of displaying a mouth of mixed teeth (heterodonty), characteristic of land mammals, they developed jaws containing uniform teeth (homodonty) but in one of several designs.

These changes took many millions of years, and for a long time these early sea-mammals would have remained physically quite different from modern whales. In the early stages of their development some may even have hauled themselves out on land to breed, in much the same way as seals do today. But as these early cetaceans spread beyond the Tethys Sea they became increasingly better adapted to their new environment.

Fossils of the first creatures clearly identifiable as cetaceans appear in the Eocene epoch, 38–55 million years ago. One of the best-known examples of these early whales, or archaeocetes, is Basilosaurus, known from fossils found by the American geologist James Harlan in the southeastern United States in 1832. Harlan assumed that the 28 giant vertebrae he found were those of a dinosaur – hence the name he chose, which comes from the Greek for 'king lizard'. Seven years later, however, a skull was found, and it was then that Sir Richard Owen, a British palaeontologist, on examining the teeth, recognized that these fossils were not reptilian at all, but those of a mammal. As a result he proposed

that the creature's name be changed to zeuglodon, from the Greek for 'yoked tooth.' During the next few years many similar fossils were discovered that together helped build up a clear picture of these early whales, or zeuglodonts. Typically they measured up to 21 m (70 ft) in length and weighed up to 5000 kg (11,023 lb). They had a flexible neck that carried a small head, and it is probable that they had a whale-like tail and pectoral fins. It has also been suggested that they may have been able to raise their head and shoulders out of the water to look around, as do many modern whales. But despite these similarities, zeuglodonts were probably quite un-whale-like in other respects. As their vertebrae lacked the support for the massive tail muscles of modern whales, it is likely that they had to wriggle their way through the water. It is also possible that, like seals, they periodically hauled themselves right out of the water.

Exciting though the zeuglodont fossil finds undoubtedly were, many experts do not believe that they provide hard evidence for the direct ancestor of the cetaceans that swim the oceans today. The complex teeth possessed by these archaeocetes, which first led Owen to identify them as mammals, suggest too high a degree of specialization. Instead, it seems likely that they must be viewed as an extinct suborder of cetacean that lived alongside the ancestors of modern-day whales. But it could be that the fossil record, which is inevitably poor for deep ocean species, has so far simply failed to provide sufficient clues to establish a link between these ancient whales and more modern forms.

Toothed and baleen whales

If piecing together the history of early cetacean evolution over 50 million years ago is possible, then it might be imagined that it would be somewhat easier to understand the more recent divergence of cetaceans into the different kinds of whale and dolphin we see today. But because the pieces of the jigsaw become smaller they are often harder to find.

Today there are two kinds of cetacean that are significantly different from each other. These are the toothed whales (Odontoceti) and the baleen whales (Mysticeti). Toothed whales, such as the killer whale,

Numerous species of toothed whale, like the killer whale, were already hunting the Earth's oceans 25-30 million years ago. This diversity is still evident in the 67 or so species surviving today.

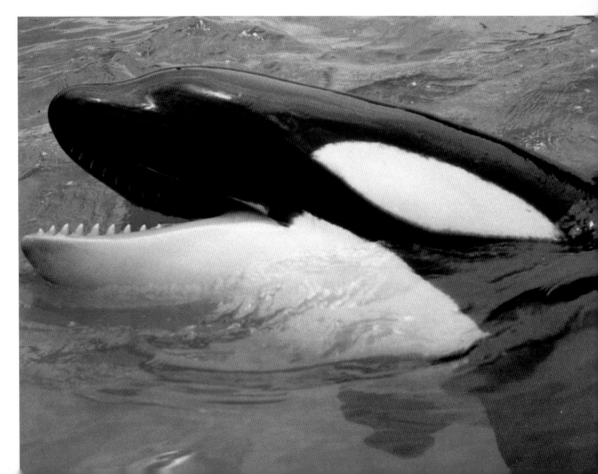

have sharp pointed teeth for catching and tearing up their prey. Baleen whales, such as the right whale, on the other hand, do not have teeth at all. Instead they have developed skin-like plates of a brush-like material called baleen. These whales gulp in huge quantities of water that is then expelled through their baleen plates to filter out anything edible.

The earliest true toothed whales for which there is good fossil evidence are called the squalodonts. Powerful swimmers, these porpoise-like whales had triangular, shark-like teeth with which to catch and consume their prey. They were particularly common around 25–30 million years ago – after which time they began to diversify into the various families of modern whale we see today.

The earliest baleen whales for which there is fossil evidence also date back to about 30 million years ago. Despite displaying certain characteristics clearly identifiable with baleen whales, these ancient whales still retained teeth and, interestingly, the foetuses of modern baleen whales still possess tooth buds. One of these early whales, Mammalodon, a cetacean that inhabited what is now southern Australia 24 million years ago, had high-crowned teeth with small projecting cusps that probably intermeshed, allowing the whale to sieve small prey items from the sea. It is highly probable, therefore, that baleen whales evolved from a toothed animal, their teeth and jaws evolving steadily to become more efficient at filter feeding. In time, baleen, which is a skin-like material, would have replaced the teeth of

these whales. But whether baleen and toothed whales actually shared a common ancestor remains uncertain.

Cetaceans today

Today, whales, dolphins and porpoises are found in every ocean from pole to pole and in many of the world's largest rivers. Some of these species have still to be observed alive and such is the magnitude of the world's oceans that it is likely that there still remain a few species yet to be identified by science.

The diversity of cetaceans is almost as remarkable as the individual creatures themselves. Most diverse and numerous are the toothed whales, which comprise six families, containing 67 species. From the mighty 50-tonne sperm whale to the tiny La Plata river dolphin that seldom exceeds 50 kg (110 lb) in weight, the variety that exists in these whales reflects their specializations to habitats as diverse as deep oceans, polar seas and the muddy waters of tropical rivers.

Baleen whales, by contrast, are far fewer in number, with just 11 species divided into four families. The lack of variety evident in baleen whales is almost certainly a reflection of their more specialized feeding behaviour. But what these whales lack in variety they more than compensate for in their sheer size. The blue whale, for example, which may weigh over 150 tonnes and measure more than 33 m (108 ft) in length, is not only the largest creature alive but the largest ever to have lived on Earth, dwarfing even the largest of the dinosaurs.

Opposite: Baleen whales include the largest creatures ever to have lived on Earth. The humpback whale, which first appeared some 5 million years ago, is one of the smaller species, but it can still weigh over five times as much as an African elephant.

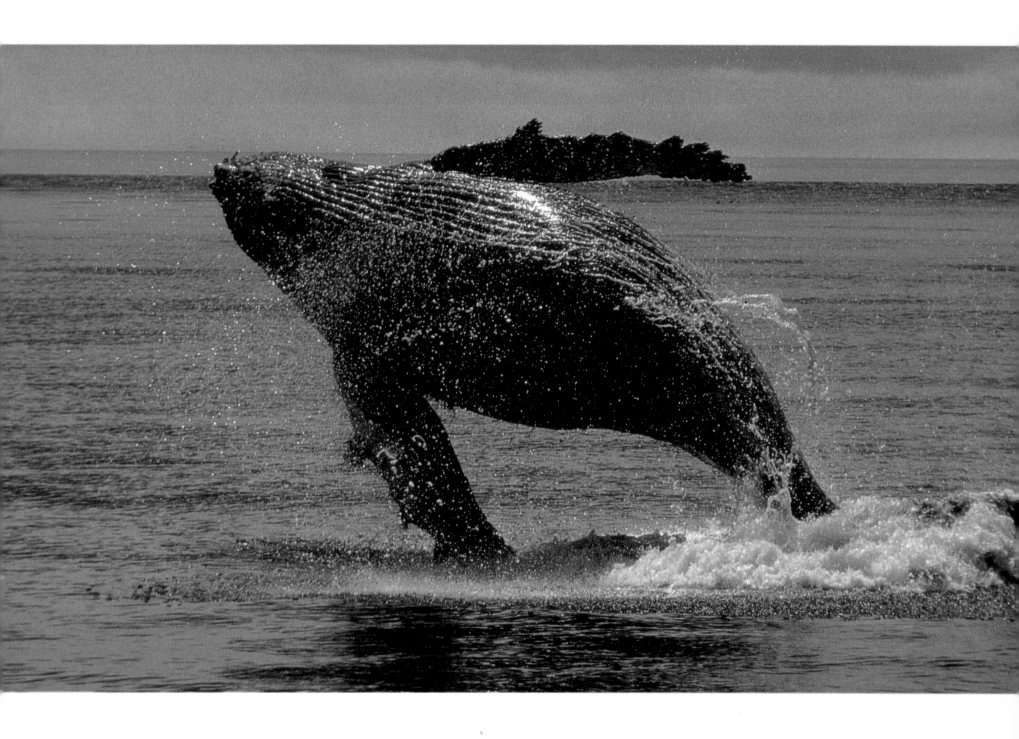

The Hunters and the Hunted

'And what thing soever besides

cometh within the

chaos of this monster's mouth, be it

beast, boat, or stone,

down it goes all incontinently that

foul great swallow of his,

and perisheth in the bottomless gulf

of his paunch.'

Plutarch, *Morals*

It is a curious paradox that the largest of Earth's creatures, the
blue whale, which can grow to 33 m (108 ft) in length and weigh
120 tonnes, feeds chiefly on a 10 cm- (4 in-) long crustacean: krill.

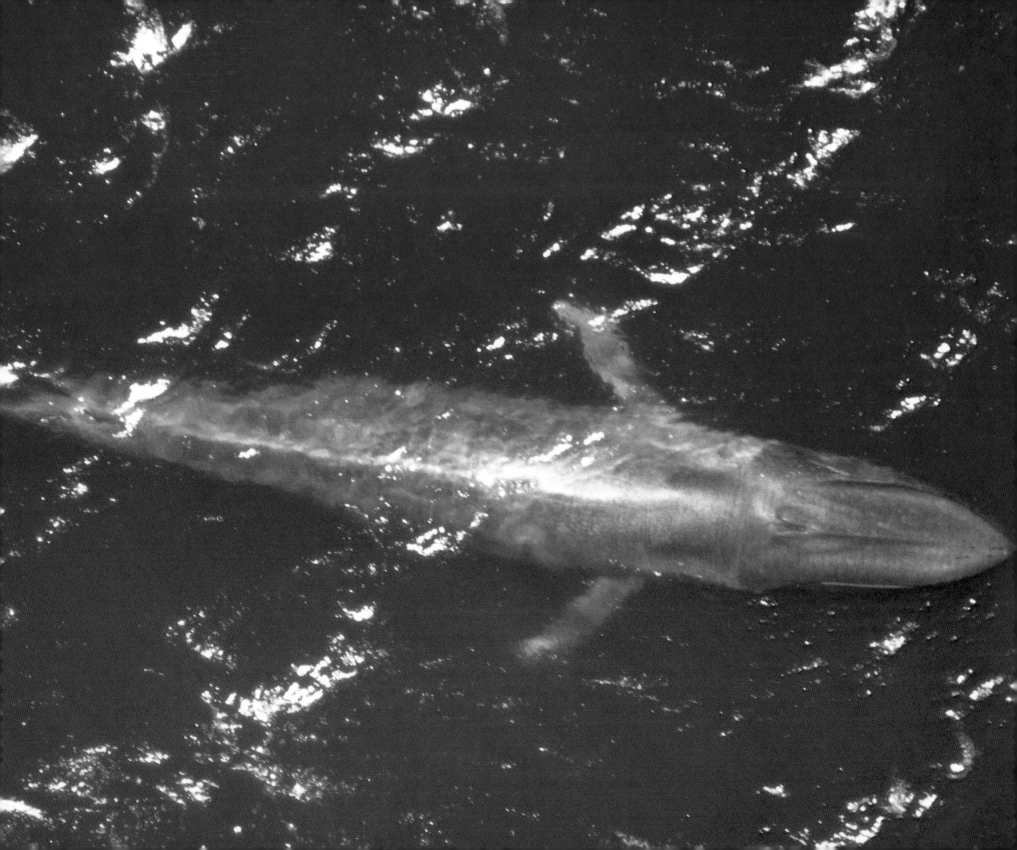

Despite the uncertainty that surrounds much of what is known about cetaceans, one fact stands out unchallenged: most are awesomely large. Some whale species – notably the blue and sperm whales – are the largest animals ever to have lived on Earth. And all but the smallest cetaceans are large by the standards of most terrestrial species. The size to which any particular species grows is determined by a variety of factors, including the availability of food, the climate, and the presence of predators. As far as land animals are concerned, maximum size is also determined by the effect of gravity. Scientists have calculated that the theoretical maximum weight of a land animal is 120 tonnes. For at this weight a land animal would have to have legs so strong and massive that it would be simply unable to move. This is, of course, a theoretical maximum and in practice few terrestrial species have approached a weight of even 50 per cent of this figure. The largest creatures known to have walked the Earth are the sauropod dinosaurs, but even these giant reptiles attained a weight of only 50 to 80 tonnes. And by far the heaviest land animal alive today – the African elephant – weighs in at a paltry 6 tonnes.

Animals that live in the deep ocean are effectively free of the tyranny of gravity. With their body weight supported by the water, their potential for growth is limited almost solely by the availability of food. As a consequence, many of the great whales grow to ten times the size of an elephant and the blue whale regularly equals the theoretical terrestrial maximum of 120 tonnes.

The larger an animal grows the more food it needs to sustain its massive bulk. And here there is an interesting parallel between the largest land animals and the giants of the sea. All the terrestrial heavyweights of today – the multi-tonne elephants, rhinos and hippos – feed on the simplest of foods, such as grass and leaves. By contrast, the largest land animals that eat complex, body-building meat – the carnivorous bears – rarely come near the 1 tonne mark. But almost all the largest whales – the great whales – are carnivores and yet, like their land counterparts, also eat the simplest of foods: the tiny aquatic creatures called zooplankton. The only exception to this interesting food:size ratio is the sperm whale, which feeds on giant squid. With few other exceptions, all the smaller species of whale have a diet that is more or less based on relatively small fish and squid.

From very early on in their evolution, cetaceans developed along two very different lines. One group, the toothed whales, or Odontoceti, retained the teeth they had inherited from their terrestrial forebears, and simply adapted them to suit their new aquatic diet of squid,

The grey whale, in common with other baleen whales, strains food from the seawater using fibrous plates of baleen.

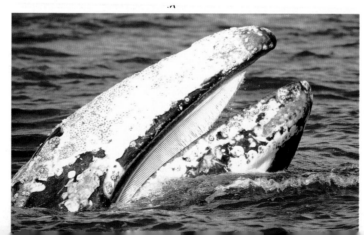

fish, crustaceans and, in one isolated case, marine mammals. The other group, the baleen whales or Mysticeti, are thought to have developed in the western South Pacific where they adopted a more specialized method of feeding, harvesting from the sea huge quantities of the zooplankton that appeared there around 30 million years ago. Over time, these whales lost their teeth, replacing them with plates of baleen through which they could strain their tiny prey from the water.

Filter feeders: the baleen whales

The 11 species of baleen whales are all characterized by the row of triangular plates of baleen that hang suspended on either side of their upper jaws. Although commonly referred to as 'whalebone', baleen is, in fact, made of keratin – the same material as that which makes up human fingernails and the outer surface of cow horns. These long, bristly, comb-like plates, which in some species number up to 400 on each side, are frayed on their inner edge and overlap each other, like the leaves of a book, to provide an efficient sieve through which water can escape but even the tiniest of creatures becomes trapped. Over time the frayed edges of the plates become worn away, but, like fingernails, baleen grows constantly throughout the whale's life.

Although all baleen whales possess baleen, they do not all catch their food in the same way. Some skim the surface waters, their mouths permanently open, others gulp in huge quantities of water to entrap their prey, and yet others grub up their food from the ocean floor.

The skimmers

Whales of the right whale family and the pygmy right whale feed mainly by skimming food from the ocean surface. The bowhead whale, for example, has the longest baleen plates of all the whalebone whales, measuring up to 4.5 m (15 ft) long. To accommodate such long plates, the lower jaw of bowhead whales has developed a vast arch and the head may make up 40 per cent of these whales' total length. The baleen of right whales also differs from that of most other species in that it is much finer and has a soft, almost silky, texture. This is because the diet of these whales is made up chiefly of minuscule marine crustaceans, such as copepods and larval euphausiids, many of which measure less than 2.5 mm (1/10 in) long.

The southern right whale has 200–270 plates of baleen on each side of its upper jaw. These finely-bristled plates often measure almost 3 m (3 yd) in length and collect even the smaller species of zooplankton.

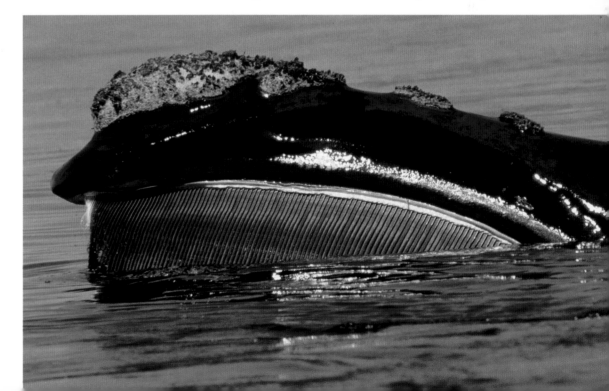

Zooplankton - the principal diet of baleen whales - includes protozoans, crustaceans and the larval stages of many other marine animals.

Opposite: The cold and often dark waters of the Arctic and Antarctic are, perhaps surprisingly, also the most nutrient-rich, and, as a result, support huge concentrations of the zooplankton on which most of the great whales feed.

A right whale feeds by swimming slowly through the water with its lower jaw open 10 or 15 degrees. As it ploughs along, the water streams into its open mouth, escaping through the baleen on each side. Any tiny organisms present in the water become trapped in the silky bristles. Periodically, the whale wipes the bristles clean with its tongue, swallowing huge numbers of the tiny planktonic creatures at a time. Right whales most often feed at the surface, the tip of the upper jaw just rippling the water as they swim slowly by. But they may also feed below the surface, diving for about 10 minutes at a time. On rare occasions they have also been know to feed at or near the seabed for, although they are best adapted to skimming their prey at or near the surface, their feeding patterns, of necessity, reflect the daily rise and fall of the swarms of zooplankton that they need to consume in such vast quantities.

Where food is plentiful, right whales may feed side by side but due to their enormous appetites they more usually feed alone. The bowhead whale, for example, which may weigh up to 100 tonnes, probably needs to consume between 1000–2500 kg (2200 –5500 lb) of food a day to sustain its massive bulk. By contrast, the pygmy right whale, smallest and least known of all the baleen whales, probably needs to consume only 50-100 kg (110–120 lb) of food per day.

Of all the baleen whales, the right whales are the most highly adapted to feed on the smaller species of zooplankton. For this reason their distribution mirrors the greatest concentrations of these creatures, which is in polar waters. The icy cold and often dark waters surrounding the Arctic and Antarctic might appear unlikely candidates for the most food-rich regions of the planet – but they are more than twice as fertile as the best pastureland. The water is indeed cold, and because it is cold it sinks to the ocean floor and slides along it. This has the effect of causing incoming warmer water to well upwards, bringing to the surface fertile silt from the seabed. Here in the long summer months a rich harvest of marine algae blooms, providing a bumper crop for the tiny animals of the zooplankton that in turn provide the staple diet of the great whales. Whales are not the only animals to exploit this rich source of food – even humans have begun to harvest krill, one of the larger and most commercially valuable components of the zooplankton – but whales are certainly the largest and most highly adapted to this food source and, as a result, most utterly dependent upon it.

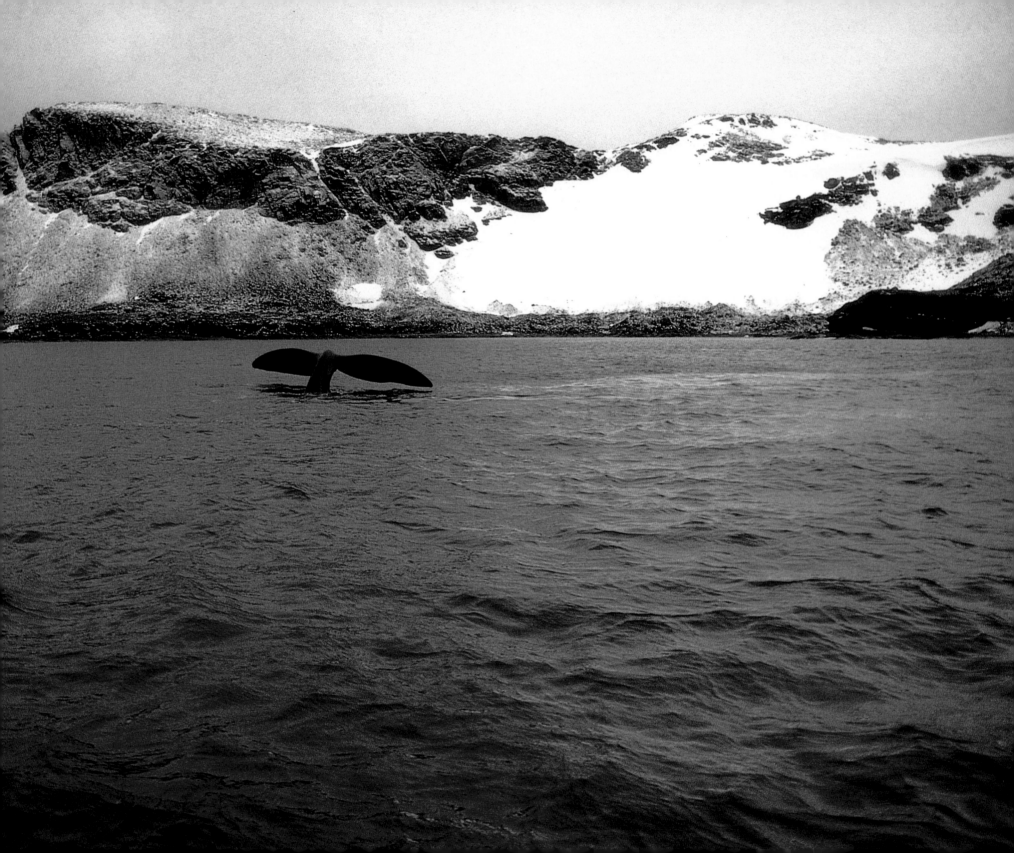

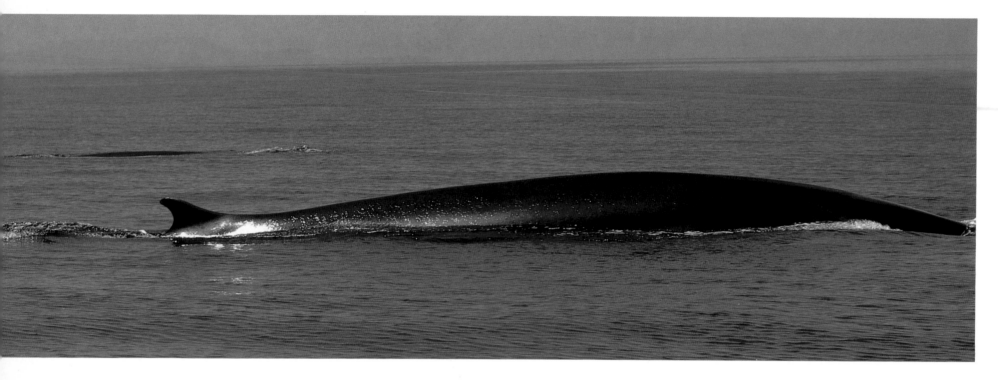

The fin whale, second only to the blue whale in size, is more gregarious than other rorquals. Groups of six or more may swim together to feed on the vast summer swarms of krill, each 21 m- (69 ft)- long adult taking about 3 tonnes of krill a day.

The gulpers

The largest of the baleen whale families, the rorquals, includes the largest of all the cetaceans, the blue whale, as well as far smaller species, such as the minke whale, which seldom exceeds 10 m (33 ft) in length and weighs less than a tenth of its giant relative. Yet despite the diversity in size of these whales, with the exception of the humpback whale, which is something of an oddity, they all bear a striking visual similarity to each other that reflects a broadly similar method of feeding.

Compared with the right whales, rorquals are far more streamlined in shape, with a small dorsal fin towards the rear of their back and relatively small flippers. Their most characteristic feature is the series of pleated throat grooves that extend from the tip of the lower jaw to a point behind their flippers. These pleats number from about 50 in the sei whale to 90 in the blue whale. They function in much the same way as the throat pouch in pelicans. As they unfold, they expand the capacity of the mouth several times over, allowing the whale to gulp in massive amounts of water as it powers itself through the water. The force of these feeding lunges expands the pleats of the whale's throat and distorts the whale's normal streamlined form to a remarkable degree. Rorquals gulp feed in this way both while swimming horizontally or diving, or while surfacing, when they

may even surge right out of the water. The whale then closes its mouth and raises its huge, rough-surfaced tongue – which in the case of the blue whale weighs as much as an adult elephant – to expel the water through its baleen and rasp away any food trapped against the inner surface of the fibrous filter.

The baleen of most rorquals is generally much coarser than that of right whales, although its texture varies between the species, reflecting an adaptation to a diet of larger prey that typically includes krill and shoaling fish. In the southern hemisphere especially, the shrimp-like krill comprises a major part of the rorquals' diet, particularly that of the blue whale, most of which feed at dusk when the krill are near to the surface. The abundance of these tiny creatures is astonishing, as lens-shaped krill 'swarms' can extend over an area of several square kilometres. Many of the rorquals, but the fin whale in particular, have developed the hunting strategy of swimming in slow lazy circles around such 'islands' of prey. With a single flipper and tail fluke breaking the surface, they herd their victims into tighter concentrations prior to striking.

Although most rorquals are gulp feeders, one exception to this rule is the sei whale. Sei whales have much finer baleen than many of their relatives, and it is noticeably silky in texture, like that of the right whales. This enables it to capture even the smallest copepods and it is these tiny crustaceans that make up a large proportion of the sei whale's diet, particularly in the northern hemisphere. It is not just the fineness of its

baleen that distinguishes the sei whale from other rorquals, for as well as gulp feeding, this whale skim feeds in a similar manner to right whales. It will also hunt schooling fish, often swimming on its side as it powers its way through a large shoal of mackerel, herring, cod or sardines. Minke whales also frequently feed on fish, especially in the northern hemisphere, although in Antarctic waters, in common with the other rorquals, krill makes up the major part of their diet.

The humpbacked hunter

Of all the rorquals it is the odd-looking humpback whale that shows the greatest variety in its hunting methods. The humpback whale is the least typical of the whales in this family. Unlike its sleeker relatives, it is a rather stout-looking whale with, as its name suggests, something of a humped back. And whereas the other rorquals all possess slim, pointed, shark-like flippers, those of the humpback are exceptionally long, rounded and robust, often growing to 5 m (16 ft) – a third of its body length. The humpback also has few, relatively

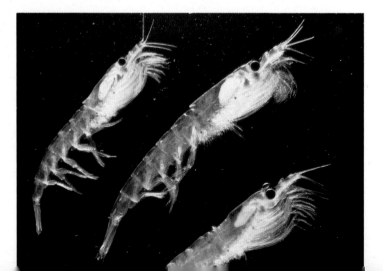

Krill feed on planktonic diatoms that abound in the cold waters surrounding Antarctica. In summer they shoal in lens-shaped swarms that can measure almost half a kilometre wide and have a density of 15 kg per m³.

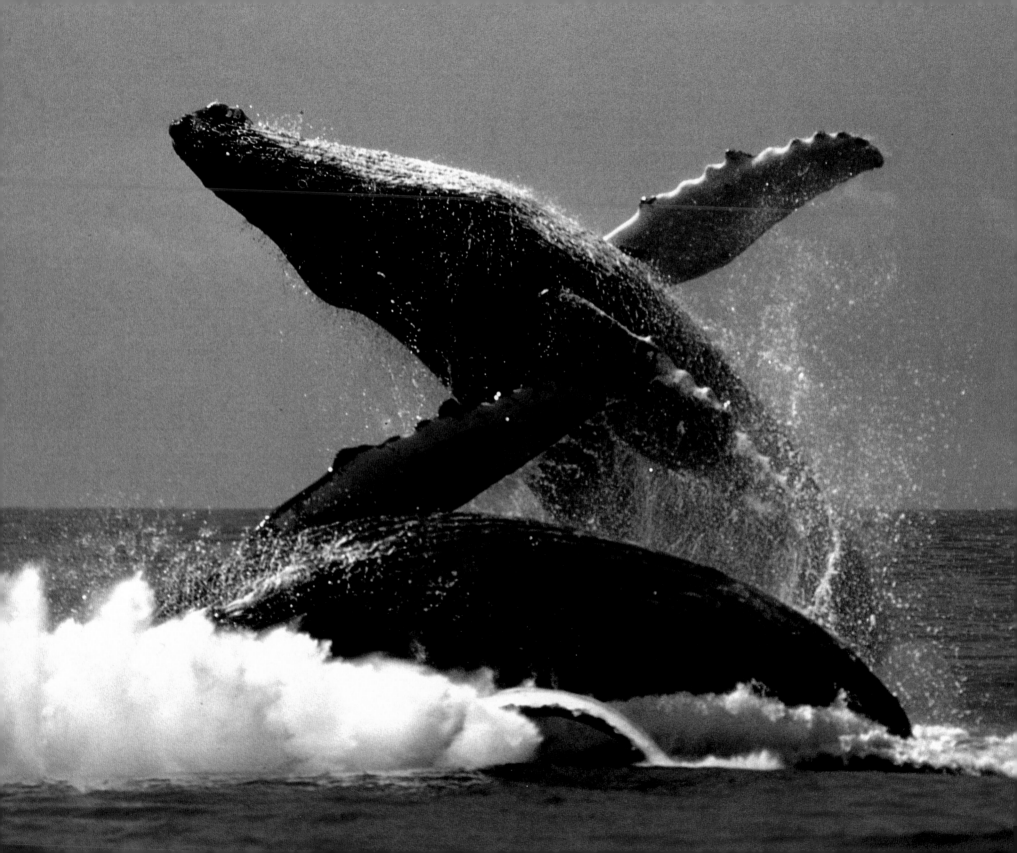

coarse throat grooves, although they are still capable of prodigious expansion.

In Antarctic seas the humpback shares much the same diet as other rorquals, but outside these waters it shows more catholic tastes. Our knowledge of the feeding methods employed by many whale species and the exact nature of their diet has been arrived at exclusively by the physical examination of dead animals. By analysing their anatomy and examining the contents of their stomachs, it is possible to put together a picture of how they hunt and the kinds of creature they catch. But such a picture can never provide a complete record of the complexities of an animal's feeding behaviour. Fortunately, the humpback whale has been studied more closely, and as a result there have been countless direct observations of its various feeding strategies.

In the icy waters surrounding Antarctica the humpback often feeds at the surface lying on its side and swimming in tight circles, like the fin whale. As if overcome by the sheer fecundity of it prey, it lolls in the water, its mouth open to scoop up vast quantities of krill. In more northern waters, however, as well as using this circling technique, small groups of humpback whales often swim parallel to each other, with their mouths slightly open, skimming the surface in much the same way as right whales. Groups have also been observed working together to herd more dispersed prey, such as shoaling fish, before taking turns to dive and lunge up, jaws agape, through a sea of food. Sometimes these lunges are so forceful that the whale emerges almost vertically from the water, a

silver trail of fish and seawater streaming from its baleen, before crashing back into the sea.

The humpback's most innovative hunting technique, and the one for which it is best known, is 'bubble netting'. When the whale finds a concentration of krill, or similar prey, it circles beneath it, rising slowly. As the whale rises, it expels bubbles of air that float slowly to the surface. As the whale continues to circle, the stream of bubbles effectively form a silver net that envelops the prey. This has the effect of concentrating the krill and preventing escape. Once the 'net' is complete, the humpback simply surges vertically through the centre, its mouth wide open, engulfing enormous quantities of its prey in one attack.

Seabed scavenger

Like the humpback, the grey whale has also been closely studied, chiefly because it is one of the more coastal of the baleen whales. The grey whale is also broadly similar to the humpback in overall size and shape, although it lacks the long, lobate flippers. Its yellowish baleen is shorter in length and much heavier than that of other baleen whales, seldom exceeding 35 cm (14 in) in length. It usually has just two V-shaped or parallel throat grooves, although individual whales with as many as seven have been recorded.

In common with many other baleen whale species, the grey whale is highly migratory and generally only feeds during the Arctic summer months of June to October. Its feeding, methods are, however, quite unlike

Opposite: As well as krill, humpback whales also feed on shoaling fish including herring. These whales employ a range of hunting techniques, including lunging forcefully upwards through a shoal of prey. Sometimes these lunges are so powerful that the whale breaches dramatically.

WHALES AND DOLPHINS

those of all the other rorquals. For although the grey whale occasionally surface feeds on small fish and crustaceans while on its travels, it is chiefly a bottom feeder, adapted to exploit the Arctic summer harvest of food that results from the long hours of daylight.

Diving in relatively shallow waters, 5–120 m (16–380 ft) deep, the grey whale feeds on crustaceans, molluscs and segmented worms – all creatures that live both on the seabed and in the sediments that cover it. On each feeding dive, the grey whale swims down to the seafloor and then turns on to its side. It then drives itself along the bottom, bulldozing its way through the sediments with its blunt snout, sending up massive muddy plumes. As it ploughs its way along the seabed, it pulls its tongue in and out like a piston to suck up the food-rich sediment through its lips and blow the water back out through its baleen. Once the whale's mouth is full, it drives itself back to the surface, filtering the mud and debris through its baleen as it rises, while retaining anything edible in its mouth. The food is then quickly swallowed and the whale takes a few breaths before diving again.

From the studies of dead grey whales it often emerged that, uniquely among the baleen whales, there was often significant wear on the baleen plates of the right side of the jaw. More recent observations of live grey whales feeding have shed light on this mystery, for they confirmed that almost all grey whales appear to be naturally 'right sided'. So that when feeding, they almost always plough the seabed with their left side uppermost,

Opposite: Grey whales are unique among baleen whales in that they feed on the seabed. Using its blunt head to bulldoze a furrow along the bottom, the whale then swims along the same path a second time, filtering amphipods, polychaete worms and molluscs from the cloud of sediment it has created.

and as a result, the constant abrasion of their baleen on the seabed wears the plates on the right side.

Pursuit predators: the toothed whales

In sharp contrast to the baleen whales, which have developed the specialized ability to sieve their food from the water, the 67 species of toothed whales use their jaws to capture free-swimming, highly mobile prey – probably in much the same way as their earliest ancestors. More numerous, more widely distributed, and more flexible in their feeding habits than baleen whales, the toothed whales also show remarkable variety in the range of food they eat.

Most of what is known about the diet of toothed whales has been learned from examination of the stomach contents of whales caught by whalers and from those found stranded. Digestion is rapid in whales, however, so often all that is left to be analysed are remains of the hard, body parts of the prey – and this may not reveal the full dietary picture. Those examinations show that individual species of toothed whale might demonstrate a preference for a particular kind of prey, but other observations have led to the discovery that, generally, they are opportunistic feeders, taking whatever is locally available and easily caught. Dolphins and porpoises, for example, generally favour shoaling fish, such as anchovy and herring, but will also eat squid, shrimp and even jellyfish. This opportunistic nature makes it difficult to define the precise diet and feeding behaviour of individual species of toothed whales

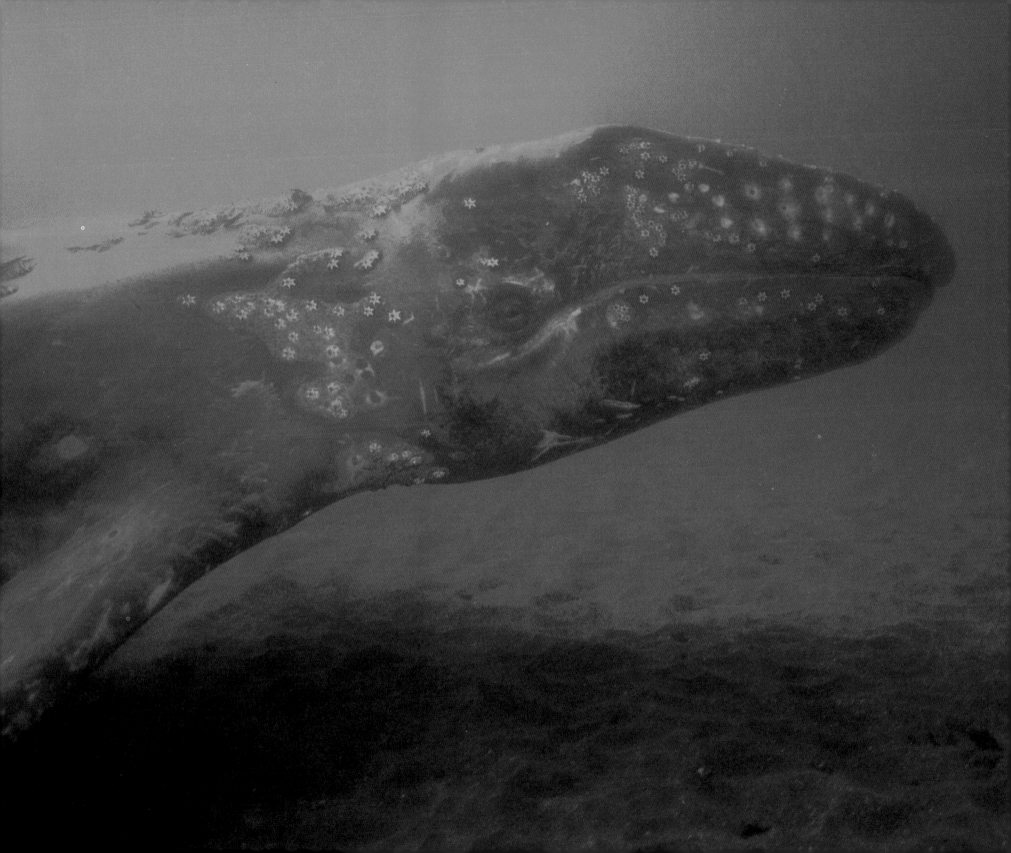

Right: Toothed whales, such as the killer whale, typically have jaws containing uniform, conical teeth with which they grasp their often fast-moving and slippery prey.

The Amazon river dolphin is unusual in that its long, thin jaws are armed with small sharp teeth at the front and more molar-like, crushing teeth at the rear. This adaptation allows it to feed both on fish and hard-shelled crabs.

– and difficult, even, to generalize about those within a single family.

Certain generalizations are possible, however, for, as with the baleen whales, it is diet that has played a large part in determining the physical form of toothed whales. Typically, squid and fish are the chief prey of all these whales, and although both may occasionally be found in high concentrations in the oceans, generally these free-swimming creatures need to be located and hunted down individually. For this reason, toothed whales have needed to develop highly specialized senses and the ability to dive deep, swim fast or with great agility, or hunt cooperatively both to detect and capture their prey. The effort required to obtain food has also had an impact on the size of toothed whales. As a result, with a few exceptions, most toothed whales are considerably smaller than baleen whales. The smallest of the filter feeders, the pygmy right whale, often exceeds

6 m (20 ft) in length. By contrast, dolphins and porpoises, which together account for more than half of toothed whale species, seldom exceed 4.5 m (14 ft) in length. And while size alone may not provide direct information about a species' feeding strategy, it at least partially reflects the quality and quantity of food consumed.

The key feature that distinguishes toothed whales from baleen whales is, as their name suggests, the presence of teeth. And the number and form of these teeth can be instructive about the type of prey the different species of toothed whales prefer. The teeth of toothed whales are unusual in a number of respects. Unlike most land mammals, toothed whales grow only one set of teeth – their 'milk' teeth – which they retain throughout their lives. Also, instead of having several different types of teeth, toothed whales usually have teeth of only one kind. In most whales they are simple, peg-like structures with a single root and are generally thought to be used for no more than grasping slippery prey. While basically peg-like, the little variation that

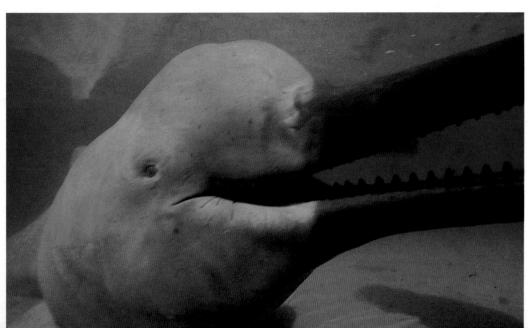

does exist in the teeth of different species, however, at least provides some clues to their diet or feeding strategy. For example, several of the river dolphins, the most primitive of the toothed whales, have somewhat flattened teeth for crushing shellfish, while porpoises have sharper-edged, more spatulate teeth that they use for slicing food too large to be swallowed whole. The study of the feeding habits of toothed cetaceans has, however, uncovered a particularly interesting paradox: the whales that feed on the slipperiest food of all – squid – generally have the fewest teeth or, in some cases, none at all. The 18 species of beaked whales, for example, which are among the more primitive and poorly studied of the

cetaceans, have adapted to a diet comprised almost exclusively of these slippery cephalopods. But in the females of these whales, the teeth never emerge from the gums, while the males of all but three species have only one pair of teeth. This trend towards fewer teeth is echoed among the squid-dependent sperm whales – a process known as parallel evolution.

Deep divers

The largest of all the toothed whales, the sperm whale, also holds the cetacean record for the deepest dives. Its prodigious ability to descend into the murky ocean depths enables it to feed on the creatures living far beyond the reach of many other ocean predators. Squid make up about 80 per cent of its diet, with octopus, fish and various crustaceans comprising the remainder. But although it is known what a sperm whale eats, how it finds its prey remains a mystery. Clearly it does not use sight, as there have been several confirmed reports of sperm whales that were found to be blind, but otherwise perfectly healthy. It has been suggested that, in the dark depths, the sperm whale's 25 enormous white teeth might act like lures while the whale swims along with its lower jaw hanging down. At first sight, this theory appears shaky: light penetrates only a short distance below the surface so it fails to explain exactly how this giant whale might attract its prey at greater depths. But some deep-sea creatures are phosphorescent, and it is possible that some of their phosphorescence may be picked up on the whale's teeth, providing a luminous

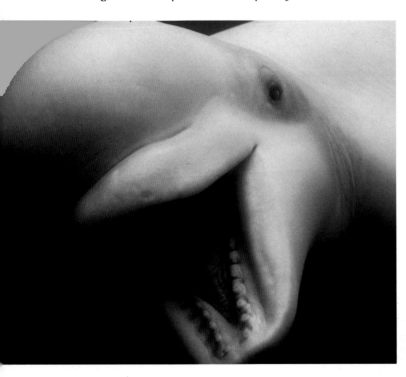

The sharp conical teeth of the beluga quickly become worn as it often feeds on molluscs and crustaceans that it forages from the seabed.

Opposite: The sleek, fasting-swimming common dolphin, like many of its relatives, often catches its prey cooperatively. It inhabits tropical and temperate waters and chiefly hunts offshore.

The deepest diving of all the toothed whales, the 11-18 m- (36-59 ft-) long sperm whale can descend over 1000 m (3281 ft), and remain beneath the surface for an hour or more, in its search for the squid on which it feeds.

lure to prey as it trawls in deep water. A more likely explanation, however, is that the sperm whale uses a form of echolocation, like ship's sonar, in which it transmits pulses of sound, listens for the echoes, and then swims towards any that reflect back from likely prey.

Another mystery concerns how it actually catches its prey. For not only is the sperm whale's jaw slung so far below its head that it is impossible for it to be able to see what it is attempting to capture, but also the sperm whale is born without teeth, only developing them in the lower jaw much later in life, as it becomes sexually mature. Furthermore, whales with broken teeth or missing lower jaws have been recovered in good health and with full stomachs. One possible solution to this puzzle is that as well as using sonar to detect food, the sperm whale can also fire especially powerful beams of sound that actually stun its prey.

Sperm whales are not the only deep-sea divers. Many of the beaked whales, are also known to hunt and feed at great depth. Baird's beaked whale, for example, dives for up to 20 minutes reaching depths of 1000 m (3281 ft) or more, where it feeds on a variety of bottom-dwelling creatures. Squid and octopus make up a large part of its diet, but various deep-water fish are also taken. Examination of the stomachs of other beaked whales show that squid is probably the mainstay of most of these whales' diet, but the difficulty in observing them underwater in the deep ocean means that relatively little is known about their feeding behaviour.

Team fishers

Hunting in the pitch-black depths of the deep ocean is generally a solitary pastime with each individual whale seeking out its own food. But when prey such as schooling fish that swim in bright surface waters can be found, many toothed whales exploit the advantages of hunting cooperatively. This strategy is most often employed by oceanic dolphins that include some of the fastest-swimming, most graceful and agile members of the cetacean order. All are highly social, and some, such as the common dolphin, congregate in huge groups, or 'herds', that may number several thousand strong.

Common dolphins are opportunistic predators that feed on a wide variety of prey from squid to schooling fish, including anchovies, herring and sardines. When searching for food, the dolphins spread out in a line, from a few tens of metres (30 ft) to over a kilometre

(1 1/2 miles) wide, and use their sonar to locate schools of
fish. Often they follow the edge of underwater
escarpments where there are concentrations of plankton,
and shoaling fish are common. Once a likely source of
food has been identified, the dolphins regroup for the
attack. A strategy commonly employed by these and
other dolphins is based on a few group members
swimming beneath a fish shoal and then driving it
upwards towards the inescapable barrier of the surface.
By circling the shoal as it rises, the dolphins attempt to
restrict the movement of their prey still further. At some
unseen signal, all the dolphins then dart into the
seething mass of fish and feed at will, snapping them up
in their sharp-toothed jaws. The mass panic that this
feeding frenzy evokes often causes the most desperate
fish to leap clear of the water – often only to be
snatched out of the air by an equally determined yet
more eager and athletic dolphin.

Wolves of the sea

The largest of the oceanic dolphins is the killer whale, it
is also the most innovative of hunters. Often referred to
as the wolves of the sea, killer whales frequently hunt in
small packs and, like wolves, cooperate to hunt prey that
is either physically too large or too numerous for a
single whale to tackle successfully. Less gregarious than
most of its relatives, killer whales are, none the less,
intensely social. Typically they congregate in groups, or
'pods' of from 5 to 25, although sometimes two or more
pods will join forces to form 'super pods'. But what they

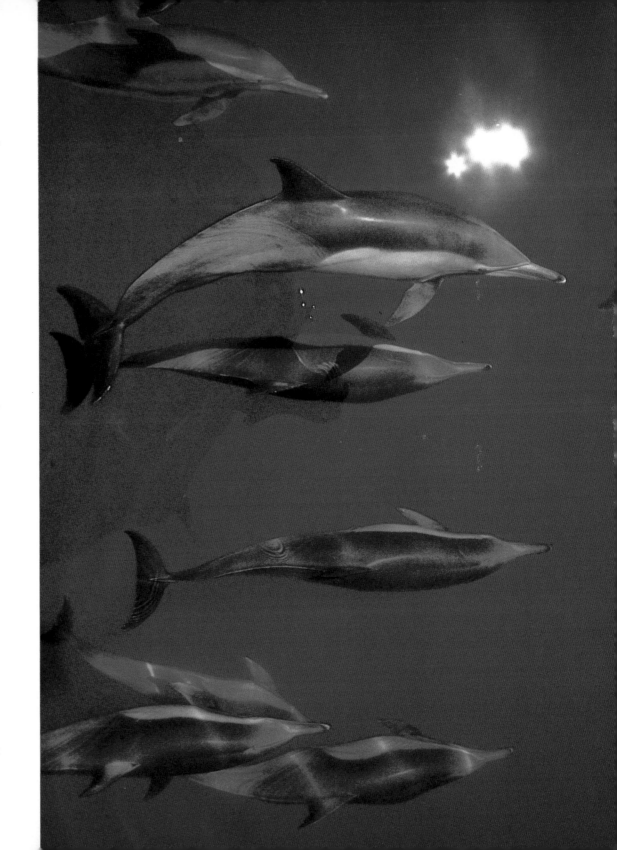

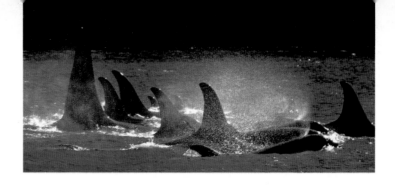

WHALES AND DOLPHINS

Highly social, the killer whale lives and hunts in relatively stable groups called 'pods'. Males are easy to distinguish from females by their towering, more upright dorsal fin.

Opposite: The killer whale has the most varied diet of any cetacean and is the only one that hunts other mammals. Highly adaptable in its pursuit of prey, this powerful predator will even risk beaching itself to snatch an unwary seal from the apparent safety of the shore.

lack in number killer whales compensate for in terms of their cooperative abilities and sheer power.

Killer whales have the most diverse diet of any whale. They will eat almost anything that they can capture, from fish and squid to birds and sea turtles. They are also the only whales that feed on other mammals. Although as a species the range of prey taken by killer whales is vast, individual populations tend to be specialists that dine from a far more limited menu based on the local abundance of certain prey and the particular learned hunting techniques of the whales themselves.

As well as hunting cooperatively, killer whales also share their larger kills with other members of the pod in much the same way as land-based, cooperative carnivores. This behaviour is particularly common among the killer whales that hunt sealions on the Patagonian coast of Argentina. In March and April vast sealion colonies gather here to breed – an annual event that has not escaped the attention of the local killer whales. Usually these whales feed on fish but at this time of year they adapt their hunting techniques to take advantage of the rich food resource provided by the sealions. The killer whales patrol the deeper water channels that they have learned run close to the shore, using their sonar to scan the area for venturesome young sealions. Provided the sealions remain in the shallow waters they are safe, but each year many of them stray into the deep water channels where they fall prey to the waiting whales.

The fact that the whales know when and where the sealions gather each year gives a clear indication of this

species' capacity for learned behaviour. But the method used by these whales to catch the young seals and immature elephant seals that breed nearby is even more remarkable. Most of the elephant seal victims are immature males that compete in trials of strength with each other in the surf. Engrossed in their own personal battles low on the beach, they appear totally unaware of the danger in the surf close by. With uncanny audacity, the killer whale powers through the water directly towards the shore, exploding through the surf to seize its prey, almost beaching itself in the process. With the seal firmly clamped in its jaws, the killer whale wriggles its way back into the water, aided by the returning waves, and carries its victim, often still alive, back out to sea.

The ingenuity of these Southern Ocean killer whales is matched by their relatives in the Arctic. For there are eyewitness accounts of small pods of killer whales hunting seals in a most individual way. By spyhopping the whales search the waters around them for a seal sunbathing on an ice floe. Once a likely victim has been found, one of the whales circles behind it while the others use their prodigious strength to up-end one side of the floe, eventually tipping the hapless seal into the jaws of the waiting whales. Although such kills are probably relatively rare, they serve to demonstrate how innovative a hunter this whale is and how effectively individuals can cooperate in their pursuit of prey.

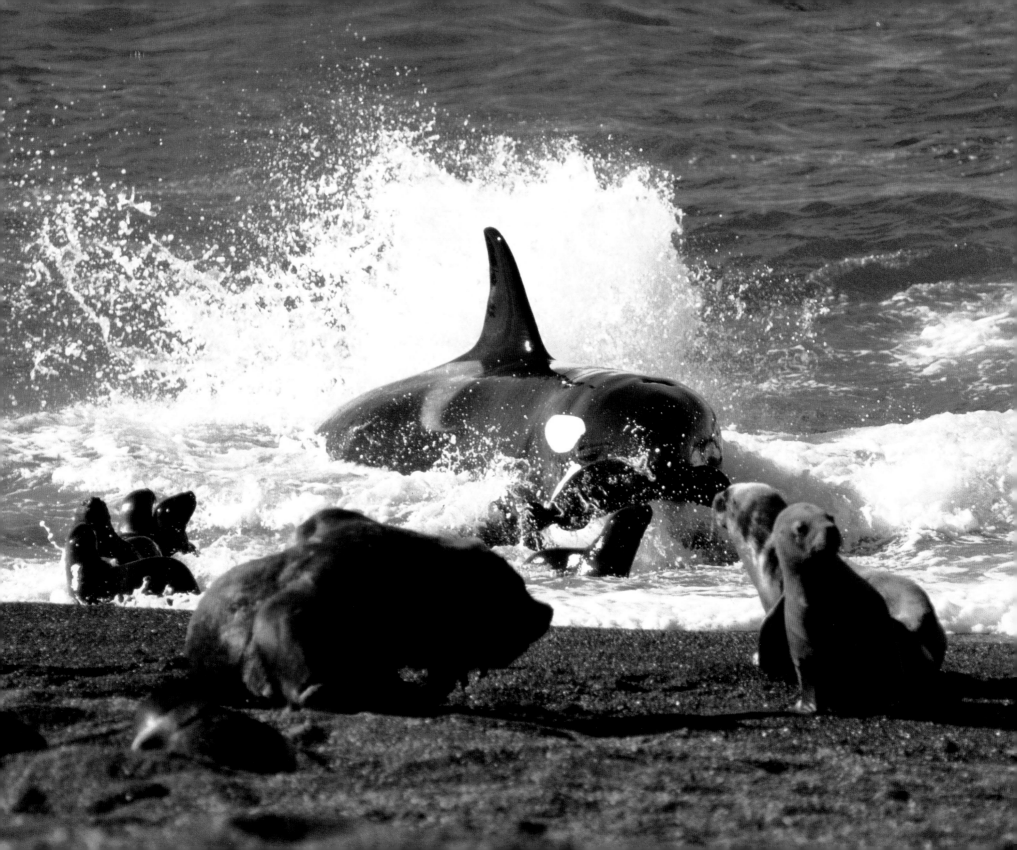

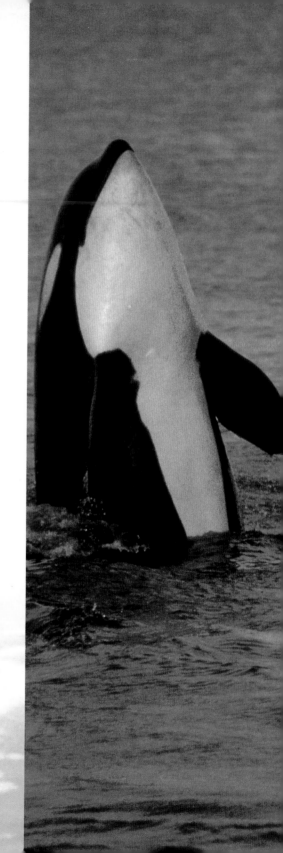

CHAPTER THREE

Sense and Sensibility

'No sooner does man discover
intelligence than he tries to involve it
in his own stupidity.'

Jacques Cousteau, *The Living Sea*

A trio of killer whales 'spy-hop', thrusting the upper part of their
bodies clear of the water, in order to view their surroundings and
locate prey.

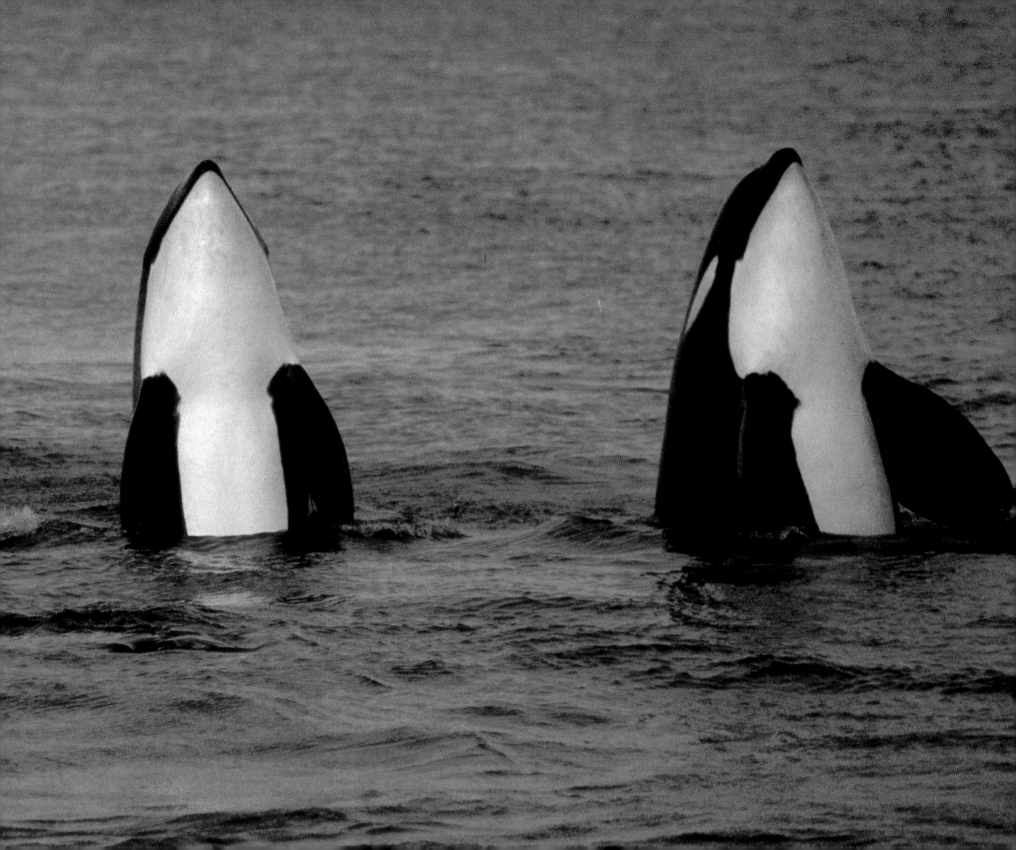

Despite the huge size of whales such as the Southern right whale, their eyes are relatively small and their vision is poor.

When the ancestors of modern cetaceans first ventured out into the oceans they took with them the full complement of senses they had developed on land. Their senses of sight, hearing, taste, smell and touch were those of terrestrial animals adapted to live surrounded by air. Once immersed in the far denser medium of water the senses of these animals would have been severely disadvantaged – just like humans are when they dive beneath the waves. Without a protective mask our vision becomes blurred and indistinct, we can hear little but the swirling, bubbling water, our sense of taste is limited by our need to keep the mouth closed, and our sense of smell becomes valueless for the same reason. Only our sense of touch remains largely intact, but even this is deadened by the pressure of the water on every part of the body. Despite similar handicaps the early cetaceans clearly coped well enough to survive – and, over time, their senses adapted to the new world around them. Just as a blind person compensates for lack of sight with increased sensitivity to sound and touch, so the cetaceans gradually refined those senses best suited to life in the water, and in some cases developed new senses specifically suited to further enhance their new lifestyle.

Vision

For terrestrial animals that are active by day, sight is often their most valuable and best developed sense. The peregrine falcon, for example, which probably has the sharpest eyesight of any land animal, can see a pigeon at a distance of 8 km (5 miles). Other creatures less able to see at great distance have eyes specially sensitive to movement and use this ability to both detect prey and avoid predators. Whales too, need to use vision for finding prey, keeping track of group members, navigating around obstacles and watching out for predators. Water, however, transmits light far less efficiently than air. Only near the surface does enough light penetrate for colours to be visible. And just 10 m (30 ft) down 90 per cent of all the light has either been reflected or absorbed and everything becomes a uniform green-blue. Deeper still, the water becomes increasingly dark until, beyond about 400 m (1300 ft), eternal night descends. Even where the water is perfectly clear – and it rarely is – the physical barrier it presents to the passage of light is such that objects become indistinct at about 15 m (48 ft), and at four times this distance quite invisible.

Depth is not the only impediment to the passage of light. The rivers inhabited by the Indus and Ganges river dolphins, for example, are so heavily laden with muddy silt that visibility is reduced to a metre or less. As a result, the eyes of these river dolphins have become largely non-functional, as they do not even possess a lens. It is probable that they can detect little more than the direction or intensity of light.

The ability of cetaceans to see underwater is thus somewhat limited – but within these limitations they have developed eyes that perform remarkably well. In addition to the challenge of seeing in water, however, a further demand is placed on the eyes of whales and dolphins – the need to see in air when they surface to breathe. As a result, their eyes have had to evolve to enable them to see both above and below the waves and in bright sunlight and the dark depths. This multi-purpose function has been achieved by developing eyes that have highly elastic lenses and that possess large pupils capable of adapting to a wide range of light intensity.

The eyes of most land animals use the thin, transparent, film-like surface layer – the cornea – as well as the lens to focus light entering them. This additional focusing occurs because the light waves are refracted (bent) as they pass from the air through the curved surface of the eye. Underwater, however, the refractive effect of water is much the same as that of the cornea, effectively cancelling out its effect, so that the task of focusing is left almost exclusively to the lens. As a result, instead of the flattened lenses of land mammals, whales have lenses that are almost spherical. In air, however, the whale's cornea does refract the light and, together with the lens that is adapted to do without the cornea's role underwater, results in the whale becoming short-sighted. This effect is minimized, however, by the fact that the surface of the eye is relatively flat, rather than strongly curved like that of land animals. Furthermore, because

the whale's eye is also adapted to see in quite dim light, the pupil is large for gathering maximum light. In the bright surface waters, though, the iris, which acts like a circular 'blind', closes almost completely to protect the retina, the sensitive light-gathering surface at the back of the eye. This contraction also has the effect of increasing depth of focus, and so helps to reduce short-sightedness at the surface.

Another adaptation to vision in low-light levels is the presence of a reflective layer of cells behind the retina called the tapetum lucidum – a feature whales share with other animals that need to see in low-light levels. It is this same reflective surface that, for example, makes a cat's eyes appear to light up when caught in the headlights of a car at night. The purpose of this layer is

The Yangtze river dolphin, or baiji, the world's most endangered cetacean, inhabits the silt-laden waters of the Yangtze River in China. Because the water is so turbid, the baiji, in common with most other river dolphins, makes relatively little use of the sense of sight.

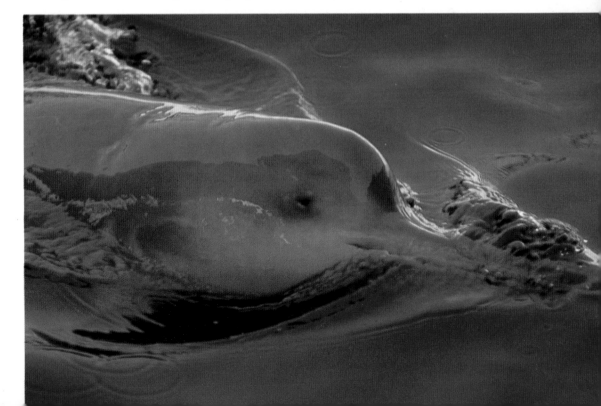

Opposite: Bottlenose dolphins are active predators. Their forward-facing eyes allow them to judge distance – at least at close range – when hunting.

to reflect back any light that passes through the retina and give it a second chance to absorb it. The retina contains two kinds of light gathering cells: rods and cones. Cone cells provide colour vision but need more light to stimulate them than rod cells, so it is not surprising to discover that whale eyes possess a high ratio of rod to cone cells. And not only are the rod cells more numerous in cetaceans, they are also larger and so able to absorb more of the available light.

The presence of cone cells suggests that whales may have at least some ability to perceive colour but this remains largely unproven, although experiments with bottlenose dolphins suggest that they can distinguish between brightly coloured objects.

On land most predatory animals have their eyes placed towards the front of their head. This allows them

The eyes of the humpback whale, like those of all baleen whales, are positioned on the sides of the head. As a result, these cetaceans have no overlapping, or stereoscopic, vision, and so are unable to judge distance accurately by sight alone.

to see the same image with both eyes – binocular vision – and so judge the range of their prey accurately. Although all cetaceans are hunters, the demands of streamlining and the pressure resulting from swimming through the dense medium of water has resulted in their eyes being placed further to the side of their heads than might otherwise have been expected. As a result, even those species with the most forward-facing eyes, such as bottlenose dolphins, have only a limited amount of binocular vision. Like all whales, however, they are able to move their eyes in their sockets and, perhaps uniquely among mammals, they can also move their eyes independently of each other. Cetaceans with bulbous foreheads can see only laterally and in extreme cases, such as the sperm whale, cannot see at all directly to the front or the rear.

Other adaptations of whale eyes to an aquatic lifestyle include a thickening of the outer layer of the eye to protect it from the constant friction of moving water and the great pressures experienced during deep dives. Also, instead of tear ducts, whales have special glands that produce an oily secretion that lubricates the eye and further protects it against the effects of friction and abrasion.

Smell and taste

Just as the visual sense involves the detection of light messages, so smell (olfaction) and taste (gustation) involve the detection of chemical messages. In land mammals these senses are quite distinct. Smell often

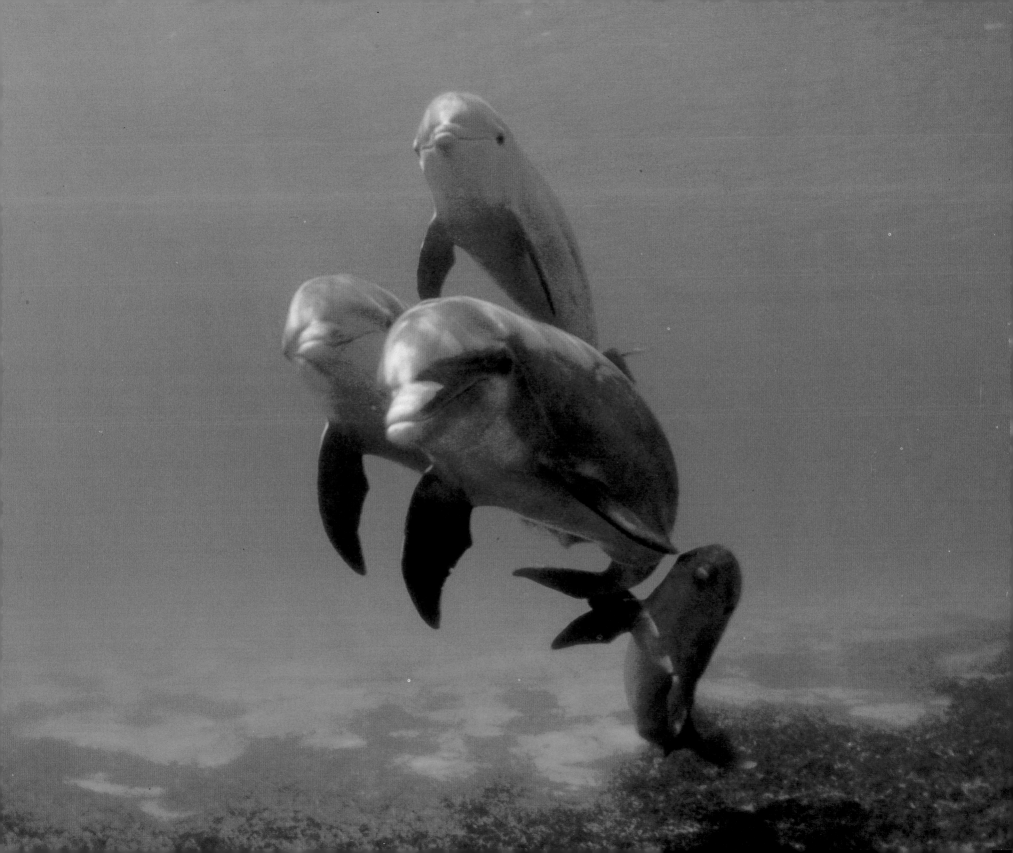

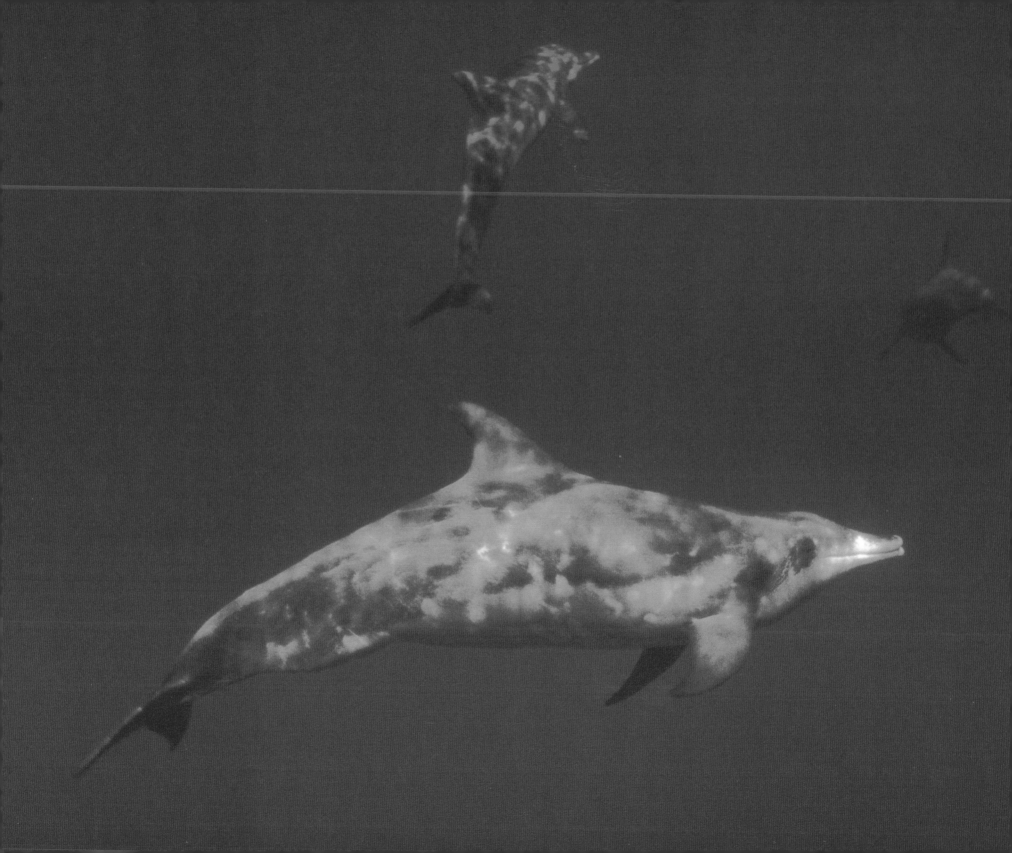

involves the long-range detection, via the nose, of airborne chemical substances, while taste provides information about dissolved chemical substances brought into direct contact with the mouth. It is possible that some cetaceans can detect scents in the air when swimming on the surface, and some experts believe that baleen whales, for example, can detect the odour of plankton-rich waters carried by the wind. Not all whales smell equally well, for while baleen whales do possess a small organ of smell, toothed whales appear to have no olfactory receptors whatsoever. Once underwater, however, all cetaceans must close off their nostrils, effectively eliminating smell from their sensory repertoire. Furthermore, cetaceans have not developed the kind of olfactory system that allows such fish as sharks to 'smell' the tiniest drop of blood diluted many thousands of times.

The sense of taste does still appear to be present, although here it is the toothed whales that appear to be better equipped than the baleen whales. Taste receptors have been found on the tongues of several species of toothed whales, and tests on dolphins suggest that they are able to distinguish between salty, sweet, bitter and sour much as humans can. Furthermore, experiments with captive cetaceans show that they avoid feeding on dead fish – which they probably identify by taste.

Certainly it is not difficult to imagine that taste could play an important part in cetacean life given the absence of a sense of smell underwater. Large concentrations of prey, for example, might be located by taste. Taste messages provided by the whales' urine and faeces could also provide useful information for other members of the species, perhaps providing a 'taste trail' that could be followed by individuals on migration and the identification of sexual chemicals (pheromones) might also give clues about an individual's readiness to mate.

Touch

Unlike smell and taste, touch is a far more developed sense in cetaceans. For although their smooth, virtually hairless skin is thick, often scarred and frequently afflicted with parasites, it is comprehensively served by a complex network of sensory nerves. Pits in the snout of some dolphins – the remains of hair follicles present at birth – are particularly richly supplied by nerve endings. Some baleen whales also show similar sensitivity around their lips. The sei whale, for example, has about 80 short, stiff lip hairs that possess complex touch-sensitive cells at their roots. From the structure and position of these sensitive areas it is probable that they are used to sense changes in water pressure and pick up low-frequency vibrations.

Direct observation of the behaviour of many species of cetacean also provides evidence for the importance of touch in their lives. In captivity dolphins clearly enjoy being stroked, and frequently rub their bodies against each other and the sides of their pool. In the wild there are also frequent reports of whales swimming beside each other, their skins touching.

Opposite: As air-breathing mammals, cetaceans, such as the rarely seen rough-toothed dolphin, must close off their blowhole while underwater. Their sense of smell is, therefore, virtually non-existent. Tests have shown, however, that some species of dolphin can distinguish different tastes.

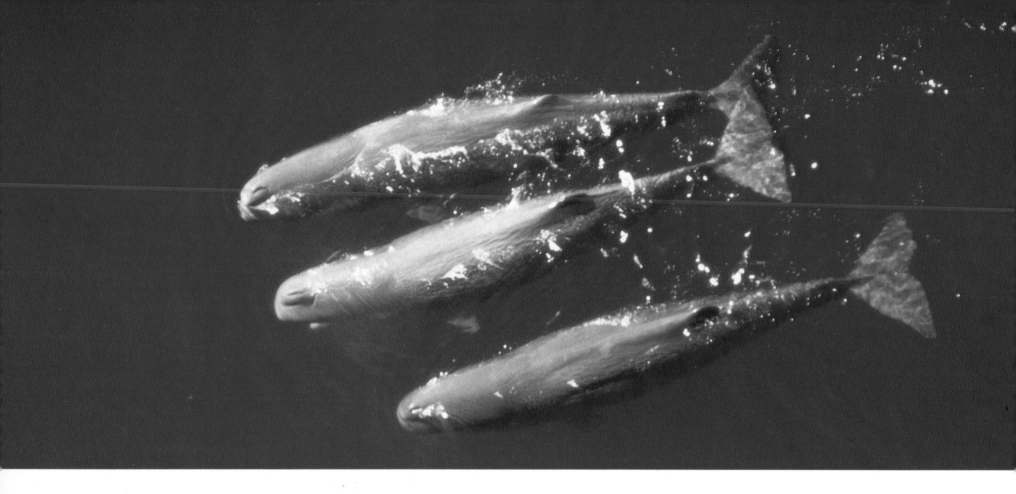

By adjusting the profile of its slug-like, wrinkled skin, the sperm whale can reduce the drag caused by water turbulence as it swims.

Apart from the social aspect of the sense of touch, the sensitivity of a cetacean's skin has two other important functions. The efficiency with which these mammals swim, especially at high speed, is in part dependent on the smooth – laminar – flow of water over their skin. Any areas of turbulence where this flow is disrupted causes drag and either slows the whale down or requires it to exert more energy to maintain the same pace. Many species of whale and dolphin, however, appear able to detect any areas of turbulence through their skin and can adjust their skin profile accordingly to correct it. Also, as any human snorkeller knows, it is important to sense when to breathe and

when not to breathe. Any mistiming of this important process can easily result in a lungful of water. The nostrils or blowholes of cetaceans are positioned on the top of their heads and they are kept closed by powerful muscles when immersed. To ensure that they open only when they are above the surface of the water, the area of skin around the blowholes is particularly well served with pressure-sensitive receptors that detect whether or not the whale is above or below the surface. In fact, these receptors appear to be so sensitive that dolphins have been observed exhaling when still a few centimetres below the surface so that almost as soon as they have breached they can inhale and dive again at once.

Hearing

Externally, cetaceans have little in the way of hearing apparatus. There are no superficial ear flaps and only the closest of inspections reveals the ear-openings – small holes, scarcely more than a centimetre across, located a little way behind each of the eyes. This, however, reveals more about the demands of streamlining than it does about the importance of this particular sense. In fact, it could be said that the roles of sight and hearing in air are reversed under water. For while in air it is light that travels far more effectively than sound, below the waves that light finds so hard to penetrate, sound travels five times more efficiently. Thus sound becomes the most informative sense through which a cetacean 'sees' the world around it.

To hear effectively underwater, and in particular to be able to judge the direction of a sound source the cetacean ear has had to change significantly from that of terrestrial mammals. This is because in air sound is effectively reflected by the skull. The direction of a particular sound can thus be easily identified as the ear nearest the source will receive the sound more clearly than the ear on the other side of the head. In water, however, sounds travel straight through the skull. A human diver therefore finds it impossible to pinpoint the direction of a sound under water – even when it is coming from an outboard motor just a few metres away. Cetaceans have solved this problem by isolating the essential organ of hearing, the cochlea, within a series of foam-filled passageways, or sinuses. These serve the

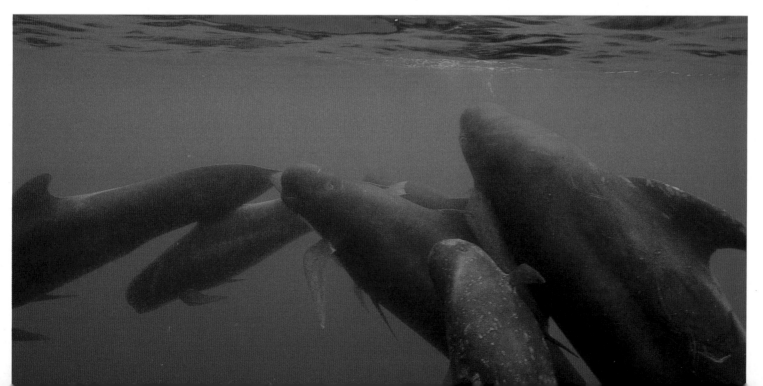

Many of the more social species of cetacean, including the short-fin pilot whale, often touch each other while swimming, suggesting that their thick, rubber-like skin is far more sensitive than it might appear.

same function under water as the bones of the skull do in air, blocking sound waves, even at great depth, and so enabling the direction of a particular sound to be identified.

Although it is known how the cetacean cochlea is isolated, exactly how sound reaches it remains debatable. The most obvious route is via the ear opening and through a small tube called the auditory meatus. But in baleen whales this tube is closed off for part of its length by a string of connective tissue. In these whales the meatus is also blocked by an ear plug made up of concentric layers of the same material as baleen, which, incidentally, like tree rings can be used to estimate a whale's age. Despite these blockages there is evidence that sound can still travel by this route to the modified eardrum. In toothed whales scientists have discovered oily tissues in the lower jaw that could also play a part in the collection and transmission of sound to the inner ear. What is known for certain is that, second only to bats, cetaceans have a more sensitive sense of hearing than any other mammal.

So what do whales and dolphins use this highly developed sense for? In the more vocal species, such as the humpback, hearing is almost certainly used for communication. Because sound travels so efficiently in water, long-distance communication becomes possible and it has been estimated that the calls of some whales are so loud that they are capable of travelling right around the Earth. Whales may also use hearing to detect sounds made by their prey and to avoid predators.

Toothed whales, in particular, also use sound, but in a much more practical way – both to locate food and avoid obstacles in their dim and often murky world.

Echolocation

Only since the development of sensitive sound-recording devices in the 1930s has the world of sound above and below the range of human hearing become known. The use of such equipment provided a solution to the puzzle of how bats, flying in darkness, could identify and catch their insect prey. For although it was known what these winged mammals were eating and when they hunted their prey, it was obvious that bats' eyes were not large or sophisticated enough to allow them to hunt in the dark using vision alone. The discovery that bats produce bursts of complex sound as they fly grew out of experiments with sonar (SOund Navigation And Ranging) to detect submarines. It became clear that these animals had evolved a means of seeing with sound in a way that was echoed by this new technology.

Despite this discovery, the knowledge that cetaceans also produced a wide range of complex sounds preceded the realization that they, too, used sound to find their prey and to navigate. This ability, generally known as echolocation, involves the emission of a series of high-energy sound pulses and then listening for the echoes bounced back from any objects struck by the sound. The strength and quality of the echoes can provide a remarkable amount of information about a subject, such as its distance, relative motion and its texture. Humans

Opposite: The humpback whale is renowned for its eerie, haunting 'songs'. These may last up to 35 minutes and be repeated, note perfect, for hours on end. Below the waves sound travels five times more efficiently than it does in air and is the chief means by which cetaceans communicate with each other.

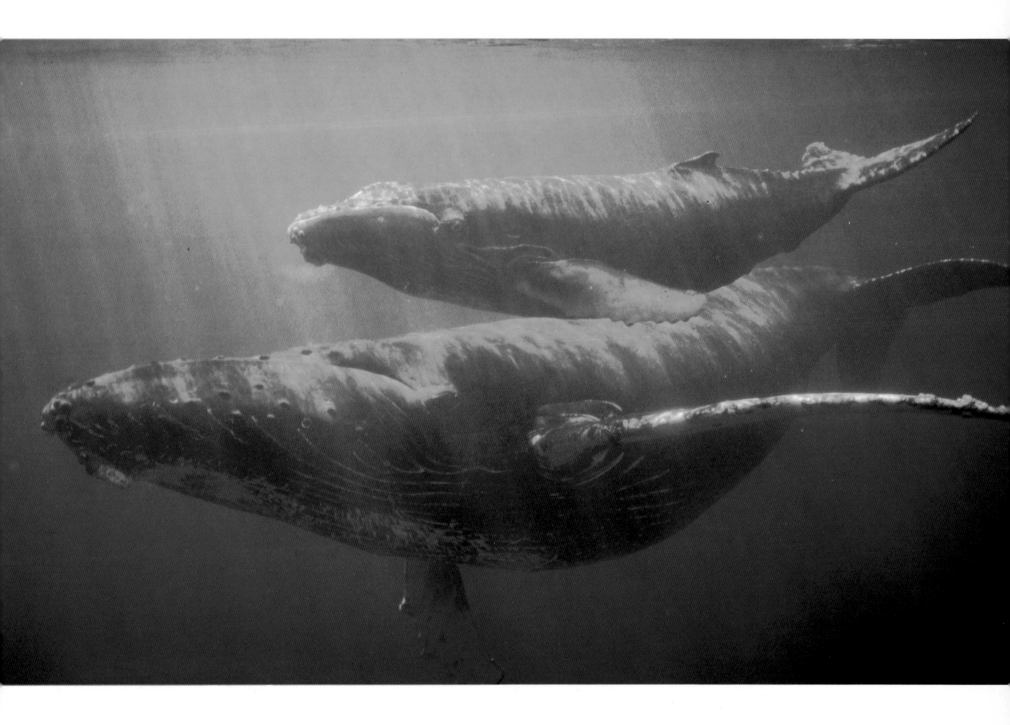

depend so heavily on sight that it is difficult to imagine what it must be like to picture the world in terms of sound. But what is clear from captive cetaceans is that by using sound alone they are able to 'see' easily as well as we do with our eyes. In one well-documented test, a dolphin 'blindfolded' with a pair of large rubber eye cups was able to discriminate between two metal spheres with a difference in diameter of only 7.8 mm (¹/₃ in) and between solid and hollow objects. River dolphins, which have poor eyesight, are also known to be able to detect and avoid copper wires just 1 mm (¹/₂₀ in) in diameter while swimming in murky waters.

The ability to echolocate appears to be present in all toothed whales although it has not been conclusively found in baleen whales. The sounds used by cetaceans to navigate or to find prey differ markedly from the whistles, grunts and moaning songs they use to communicate with each other. Unlike bats that echolocate using extremely high-pitched calls beyond the range of most people's hearing, the 'clicks' used by cetaceans are at least partially audible. The nature of these sound clicks varies between species: sperm whales produce fewer, longer clicks and dolphins make much shorter but rapidly repeated clicks. Exactly how these

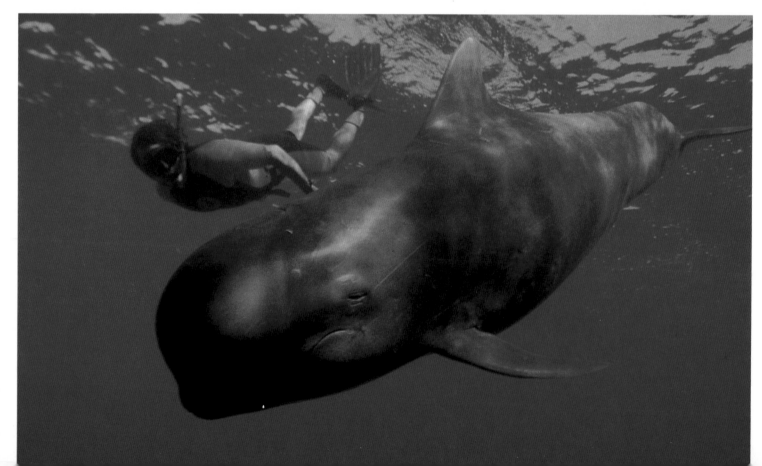

The bulbous forehead, or melon, of the pilot whale contains fatty deposits that are thought to be used to focus the bursts of sound it uses to echolocate.

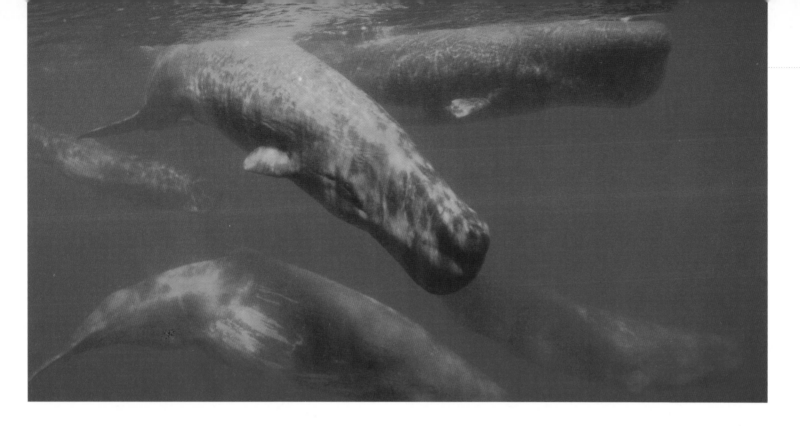

The sperm whale illuminates the lightless waters in which it hunts with sound. By producing a series of loud clicks, and then listening for echoes bouncing back from its surroundings, it can build up a 'sound picture' of the otherwise dark, invisible world around it.

sounds are produced is a matter of some debate. Some experts suggest that they originate in the larynx while others claim that they are produced by nasal plugs in the air passage to the blowhole.

These bursts of sound span a broad band of both high and low frequencies – most of which are outside the range of the human ear – and they are fired out in a more or less cone-shaped beam. It is also believed that toothed whales use the large fat deposits located in their foreheads to focus this beam of sound, enabling them to choose which objects or areas they want to 'illuminate'.

Initially, the presence of these large fatty deposits presented scientists with something of a mystery. Fat stores in any animal represent a serious investment in terms of energy, and are usually laid down after gorging on plentiful food supplies as an insurance against times

of shortage. But these particular fat deposits appear to have no clear value to the animal in terms of energy reserve, despite the fact that, in the sperm whale, they weigh several tonnes. Furthermore, the fact that the size and position of these fat stores has required such major modifications of the skull suggests that they must offer another major benefit to the animal.

The ability to focus sound accurately and so catch prey more effectively would be just such a benefit – one that would warrant the development of what is otherwise, in terms of energy, a very 'expensive' organ. The presence of a similar fatty deposit in the lower jaw of toothed whales, which some scientists believe plays a part in hearing, could be used exclusively in echolocation, detecting the echoes that are reflected by the whale's surroundings.

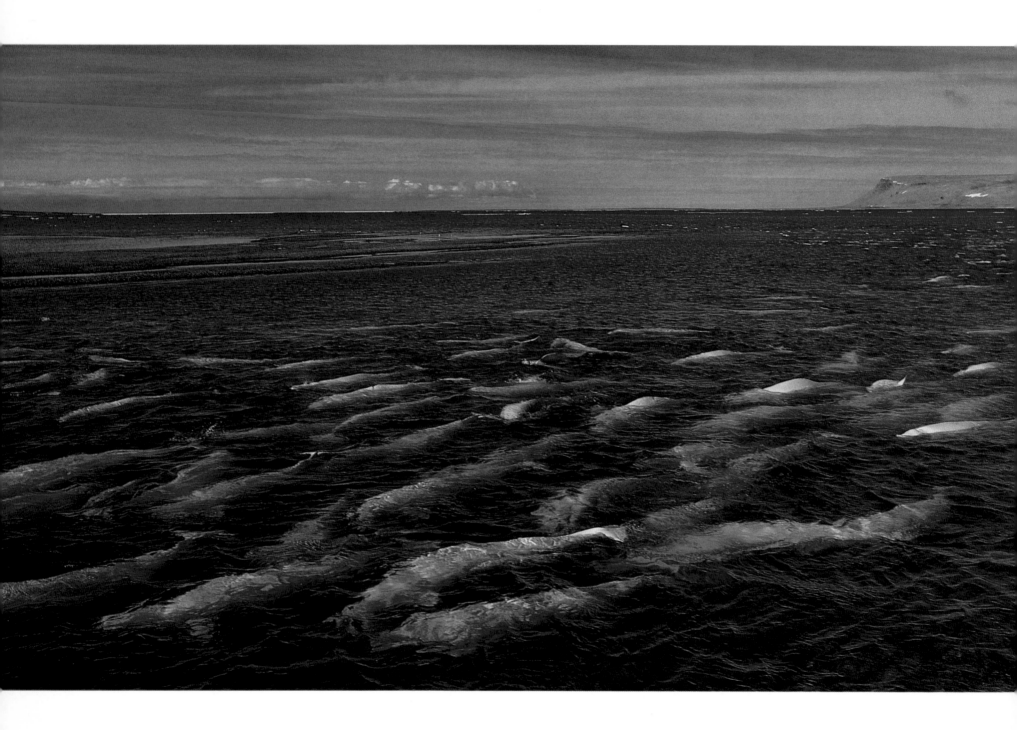

The study of dolphins at sea suggests that echolocation is used in a variety of quite different ways. For much of the time relatively simple, low-frequency sounds of almost pure tone are emitted to provide the dolphin with a general picture of its surroundings, such as variations in the relief of the seabed and water depth. The volume of the sounds determines the dolphin's range of view, from the immediate vicinity to a range of over half a kilometre. If the dolphin detects something of interest, such as an echo of what could be a shoal of fish, it will emit more rapidly repeated clicks of a broader frequency. The echoes provided by these sound pulses serve to fill in a little more detail about the object. As the dolphin moves closer to its target it will focus its beam of sound more tightly and use higher frequencies. High-frequency clicks provide echoes that reveal the maximum information about a subject, but they can only be used at close range as their energy is rapidly absorbed by the water.

Magnetic sense

Echolocation is evidently an immensely powerful sense with which toothed whales can obtain massive amounts of information about the world around them. But to explain how a large number of whales, including many baleen whales with no echolocation abilities, navigate the oceans on their seasonal migrations requires a further almost equally esoteric sense: that of magnetic sensing. Scientists have long recognized that many creatures from bacteria to birds have the ability to detect the Earth's magnetic field and orientate themselves in relation to it. Studies of the routes taken by many cetaceans on their long-distance migrations suggest that they too have this remarkable ability. If these magnetic lines of force simply ran due north–south, then establishing a relationship between them and the similar direction of migration taken by many whales would not be easy. But in areas where there are geological formations rich in iron the magnetic field is distorted. Such geomagnetic anomalies litter the oceans, especially in areas where continental drift is taking place, around continental shelves and sea mounts. The fact that migrating whales, such as the fin whale for example, have been observed following the 'magnetic contours' of such geomagnetic anomalies rather than travelling along a more direct route provides good evidence for cetaceans possessing a magnetic sense.

Geo-magnetic sensitivity is thought to stem from the presence of tiny crystals of iron oxide (magnetite) in or near a whale's brain. Such crystals have been found in the outer brain tissue of several species. The crystals appear to act like miniature compasses, aligning themselves with the magnetic lines of force that embrace the planet. An awareness of the alignment of these crystals then allows the whale to orientate itself accordingly. The combination of this physical evidence with the behavioural studies of whale migration suggests that whales have indeed developed this remarkable sense.

Opposite: Using sound both to communicate and echolocate, the highly social beluga is one of the more vocal of whales. Its remarkable twittering calls, made both above and below the surface, prompted eighteenth-century whalers to dub it the 'sea canary'.

Intelligence

At the heart of the fascination many people have for whales and dolphins lies the notion that these amazing marine mammals are, in some special way, intelligent. This popular viewpoint has gained so much currency that it is often accepted as an indisputable fact. Yet despite the fact that intelligence itself is so difficult to quantify, the direct evidence for cetaceans being especially intelligent is relatively scarce.

The ease with which many cetaceans can be trained in captivity is often cited as evidence for the high intelligence of these aquatic mammals.

Many commonly held beliefs about the relative intelligence of different species simply highlight a lack of understanding of animal behaviour. To many people the degree to which an animal can be trained suggests something about its intelligence. Certainly the ease with which captive dolphins and killer whales learn to perform complex tricks has convinced many people that these animals possess a remarkable intellect. By using this criterion alone, it follows that dogs should be more intelligent than cats – a highly subjective conclusion.

A less subjective measure of intelligence favoured by some researchers is brain size, but even here the arguments are clouded. The human brain, for example, is typically three times as heavy as that of cow and thus supports the view that humans are more intelligent than cattle. The brains of cetaceans are also large. A sperm whale, for example, has a brain more than five times heavier than our own, but is it five times more intelligent? This argument further dissolves when one considers that this phenomenal brain size is also matched by the African elephant. Furthermore, if brain size is compared as a proportion of body weight, a cow should be four times as intelligent as the largest toothed whale. Clearly, brain mass alone is no guide to an animal's intelligence.

Perhaps more important is the relative complexity of an animal's brain. From our understanding of the function of the human brain, it seems that it is the development of the outer part of the brain – the cerebral cortex – that sets it apart from the brains of

other mammals. It is here that the analysis of sensory information takes place and conscious responses to various stimuli originate. At first sight the cetacean brain appears to be similarly developed. The cerebral hemispheres are both large and possess the convoluted folding that is characteristic of the human brain. The cortex is, however, much thinner, and on closer inspection the nature of the folding bears a greater resemblance to the brains of cows and sheep than it does to those of humans. More detailed neurological study of cetacean brains also shows them to be relatively primitive in structure. So, even disregarding size, it is difficult to build a strong case for cetacean intelligence based purely on the anatomy of their brains.

Inevitably the argument must return to the question of what exactly is meant by intelligence. And would any human definition be relevant to a creature that lives in a world so very different from our own? In its broadest sense intelligence is usually thought to imply some form of understanding, the comprehension of cause and effect – in other words, the ability to think. The ability to communicate is also widely associated with intelligence as it can provide clear evidence of conceptual thought and the transmission of ideas symbolically. The clever tricks that certain species of cetacean perform, simply demonstrate the ability to imitate – a skill even rats and pigeons possess.

Despite the fact that many species of whale produce a wide range of vocalizations, there is no evidence that any of them possess even a rudimentary language. In an experiment similar to that carried out on chimpanzees, however, researchers taught two bottlenose dolphins a form of sign language to test their ability to understand sentence patterns of up to five words. This research did indeed show that the dolphins could understand semantics and syntax – the underlying rules of meaning. But it can only be left to conjecture whether this proves anything else other than that dolphins have an impressive ability to learn the associations between particular signs and the actions they were required to perform.

The case for cetaceans possessing high intelligence must, therefore, be considered unproven. Some species are undoubtedly more resourceful and have a greater capacity for learning than others, but the widely held view that whales and dolphins are intelligent *per se* seems to be a fallacy.

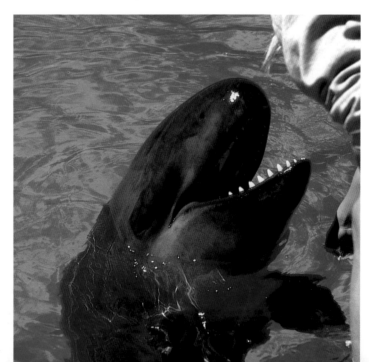

False killer whales are one of several species of cetacean that have been studied and trained intensively in captivity.

Social Behaviour

'Here they saw such huge troops of
whales, that they were forced to proceed
with a great deal of caution for fear they
should run their ship upon them.'

Willem Cornelius Schouten, from John Harris's

Navigantum atque Itinerantum Bibliotheca

Bottlenose dolphins are among the most social of all cetaceans
and frequently gather in schools numbering many hundreds.

All cetaceans are essentially social animals that spend most of their lives in close contact with other members of their species. For some whales these groupings may comprise pods of just two or three individuals, while others gather in huge schools numbering a thousand or more. In all cases, however, sociability is an evolved form of behaviour that returns a benefit to all the members of the group. To really understand cetacean sociability, however, something needs to be known about the status of the individuals that make up a group, and why or how they are interacting. But this is not easy to assess. For example, by observing a school playground it could be assumed that juvenile humans are essentially gregarious – but the true picture is much more complex. Within a crowd of playing children there may be any number of social sets, from age-mates to siblings to temporary associations, such as teams. Then, at the end of the school day, the wider group fragments as the individuals return to their families, perhaps to reunite later in smaller friendship groups. Studying free-swimming cetaceans in the ocean, however, is a more formidable challenge than observing such aspects of human society. This is chiefly due to the difficulty of identifying individuals and estimating their age and sex. For only with this information can social relations between group members be evaluated. The species that have received most attention are often those where this information is most easily obtained. The sex of killer whales, for example, is easy to determine as the males have huge, upright dorsal fins easily distinguishable from the shorter, more curved fins of the females. Humpback whales, while not so easy to sex, can be recognized individually by the characteristic markings on their tail flukes. More is also known about those species that live in coastal waters or those that can be kept in captivity, such as the bottlenose dolphin.

In the future, however, the use of DNA fingerprinting and satellite tracking should make it possible to learn more about the social relationships of a far wider range of species. But for the present, since cetaceans are mammals, the knowledge gained from studying the behaviour of their terrestrial counterparts can be used to give some insight into the ways in which whales and dolphins operate socially. From such studies it is known that many different factors influence the sociability of any species. Important factors include the nature of the habitat, the distribution of food, the threat posed by predators and the need to find mates and to care for offspring – all underpinned by the benefits of group living, such as the ability to share learned behaviour and offer mutual support.

The influence of the habitat on group size is quite easy to see among the dolphins. River dolphins, such as the Indus and Ganges river dolphins, are among the least social of the toothed whales. Often living an almost solitary existence, they seldom congregate in groups of more than ten. This is because they inhabit shallow rivers in which their prey is distributed more or less evenly. Furthermore, because their aquatic world is so closely bounded by richly vegetated banks and inlets,

their habitat is far more varied than that of open waters. This makes it much easier for individuals to hide from the few large predators that share their freshwater home, and so allows the dolphins to be more self-reliant.

Coastal dolphins, such as the tucuxi, benefit in the same way as river dolphins from the varied topography of their habitat, but, at the same time, predators are more numerous here, and the dolphins' own prey tends to be more scattered. To protect themselves while they

range further in search of prey, these dolphins tend to form social groups, typically 5–20 individuals.

By contrast, the open-ocean dolphins, such as the spotted dolphin, live in open, often featureless, waters quite unlike any terrestrial habitat. Here the threat from predators, such as sharks, is much greater and while the dolphins' prey tends to be very concentrated it is even more widely distributed. For these dolphins the benefits of group living are even greater and, as a result, they

The sociability of species, such as the Atlantic spotted dolphin, is probably an evolutionary adaptation to their vast open habitat, where prey is concentrated but widely distributed.

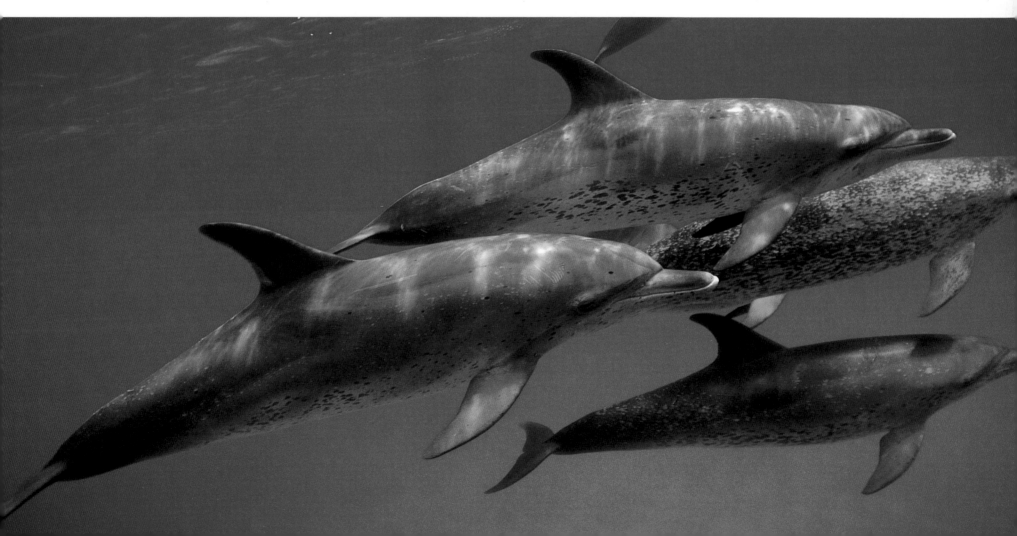

typically congregate in schools of a 100 or more. By cooperating with each other they can split up and search vast areas of the ocean for prey. Similarly, with so many pairs of eyes and ears to keep watch for predators, the chances of an individual being taken unawares by a stealthy shark are greatly reduced.

Spinner dolphins

The flexibility of spinner dolphins' social groups sheds further light on the relationship between group size and habitat. Studies of these dolphins in Hawaii have shown

Spinner dolphins show great flexibility in their social groupings, varying group size to suit their habitat and behaviour.

not only how they adapt their behaviour to suit the habitats they exploit, but also that they cooperate with another cetacean species, the spotted dolphin.

During the day, groups of about 20 spinner dolphins – often of the same sex and age – swim slowly into bays and inlets to rest. And although dolphins do not sleep in the accepted sense they do become relatively inactive and less alert. By staying close to the shore at this time they are at less risk from predators. Spinner dolphins do not feed inshore, however, and as evening draws in they prepare to go hunting. This is when they perform the remarkable aerial displays after which they are named. Launching themselves out of the water, they spin elegantly in mid-air before crashing back into the sea. As well as spinning, groups of these dolphins will also join up and swim rapidly in a characteristic zigzag pattern. Both these displays seem to reinforce the cohesiveness of the group. The spinners then head offshore where they join up with other groups to form a hunting school many hundreds strong. These large congregations coordinate their efforts to help find the schooling midwater fish on which they feed.

When spinners are far out in the Pacific, however, they cannot return to the security of the coast to rest. Here, large schools of spinners have been seen congregating with spotted dolphins. As the latter rest by night and feed by day it has been suggested that this example of inter-species sociability offers a measure of protection against predators – as by day or night there will always be dolphins on alert for signs of danger.

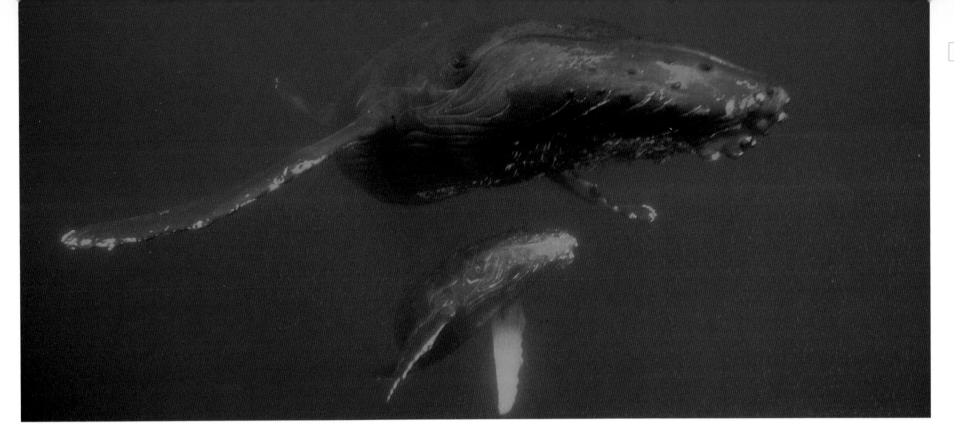

Groups within groups

The degree of sociability exhibited by spinner dolphins is typical of many species of toothed whale that feed on shoaling fish. Baleen whales, on the other hand, tend to be far less social for the simple reason that the swarms of krill that comprise a significant part of their diet are seldom large enough to feed more than two or three of these massive mammals in any one location. Any benefit gained by a large group being able to search a wider area of ocean for food is offset by the fact that the whales would have to compete with each other as there would not be enough to go around. The unusually large groups of baleen whales that gather where particularly dense concentrations of food do occur are temporary congregations of much smaller social units.

In all cetaceans the fundamental social group is that of mother and calf. Calves are seldom weaned before they are about four months of age and the young of some toothed whales continue to suckle for years. This establishes a bond that is often maintained even after the calf matures. Males, on the other hand, are often peripatetic – they move from place to place, spending short periods of time with a number of different groups of females and young. As a result, many cetacean social groupings, such as those of the long-finned pilot whale, are matriarchal in structure, with the female offspring eventually usurping their mothers' position while the male calves leave the group once mature. These groups are strengthened by the presence of aged females that have passed the point at which they can breed: a rare

Female humpback whales form close ties with their calves and the pair remain inseparable for many months.

Opposite: It is the exuberant 'playfulness' of dolphins that has long endeared them to humans. Much of this behaviour, however, has a more serious purpose related to the learning of vital survival skills.

Bottlenose dolphins frequently ride the bow wave of fast-moving boats, but whether they do this for 'fun' or to exploit the energy-saving benefits of a free ride is open to conjecture.

occurrence in the natural world. Using their experience, these females can help the group find good areas to feed and help with navigation when on migration. Group composition here, therefore, is closely related to breeding behaviour. Similarly, humpback whales often form small groups comprising females and young, but with the difference that the group is escorted by a dominant male who will protect his 'harem' from rival males. In such species these small, highly stable groups will periodically join up with others to form 'communities' either in times when food is concentrated and plentiful or to breed and give birth to young.

Social status

In any social grouping there has to be some form of hierarchy to avoid conflict. Individuals need to know their position in the hierarchy and the rights and privileges that are associated with their rank. And much

of the more demonstrative social behaviour of whales is directly related to the establishing of rank. For example, competition between humpback whales often involves males lunging at each other, with their throat pleats extended to make them look more menacing, and striking each other with their tail flukes. Sperm and beaked whales also engage in similar trials of strength, often using their teeth to inflict serious wounds on their rivals.

Studies of bottlenose dolphins also confirm that there is a clear 'pecking order'. Like wolves in a pack, size is usually the key factor determining rank, but an individual's status appears quite fluid, changing with health, reproductive ability and the presence of other group members. And like their canine counterparts, these dolphins also exhibit various kinds of behaviour to assert their dominance over rivals, including biting, ramming, jaw clapping, tail slaps and body checks.

Play behaviour

Among humans social behaviour is also strongly associated with recreation – and it is tempting to ascribe similar behaviour to other species. The willingness with which humans anthropomorphize other animals generally, and cetaceans in particular, has led to the view that some of the more extrovert behaviour of whales and dolphins is evidence of 'play'. Play behaviour is typical of many higher mammals and far from being purely 'fun' serves a vital role in the learning of survival skills. Infant herbivores such as baby antelope frequently gambol about, sprinting and leaping in what appear to

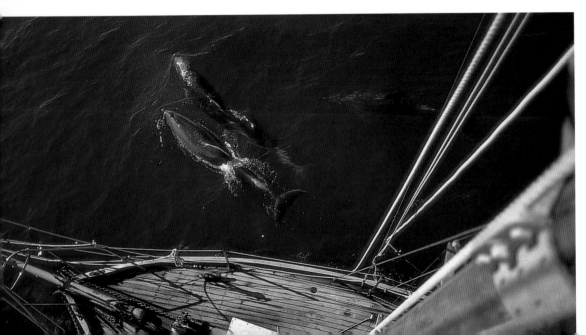

be displays of pure *joie de vivre*, but these animals are actually practising vitally important skills that may one day save them from the claws of a lion or the jaws of a cheetah. Similarly, the sight of wolf cubs rough and tumbling with each other, while undeniably appealing, is actually the process by which they learn the social skills they will one day need to establish their rank in the hierarchy of the pack. By extension, the apparently exuberant behaviour of many cetaceans, particularly dolphins, probably has far more to do with learning social skills and acquiring the necessary agility to pursue prey than anything else.

One example of so-called play behaviour that is less easy to explain is the habit many dolphins and porpoises have of riding the bow wave of fast-moving boats and ships. By manoeuvring into the area of water just in front of a vessel and then setting its flukes at just the right angle, a cetacean can hitch a free ride, and, with no effort of its own, be pushed along at whatever speed the ship is making. The eagerness with which groups of dolphins in particular compete for just the right spot to bow ride, together with their evident ability to out-accelerate the vessel, suggests to many observers that they are simply having fun. A more rational view, however, might be to assume that if the craft is travelling in much the same direction as the dolphins wish to travel, then the dolphins are merely taking advantage of the free ride and exploiting the opportunity to save valuable energy – for no animal apart from humans expends energy unnecessarily.

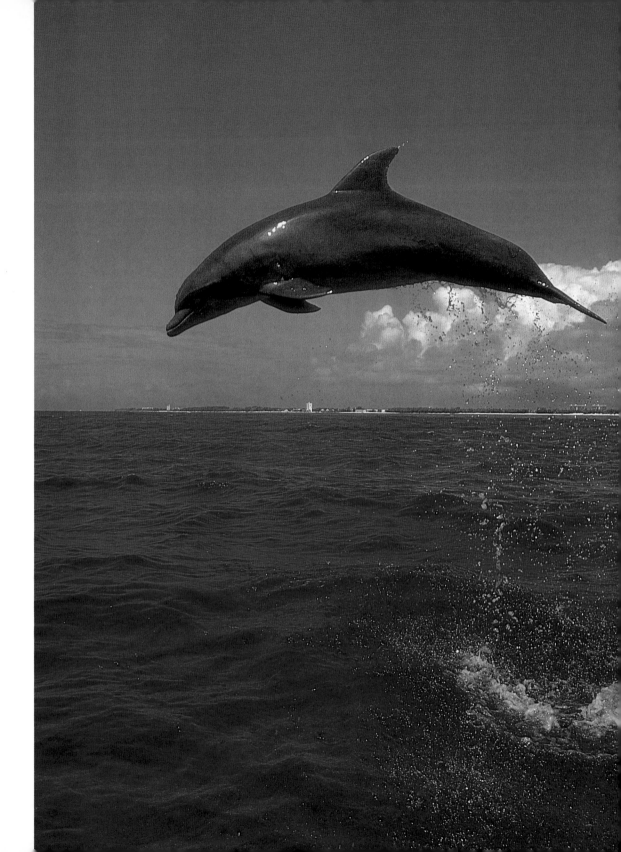

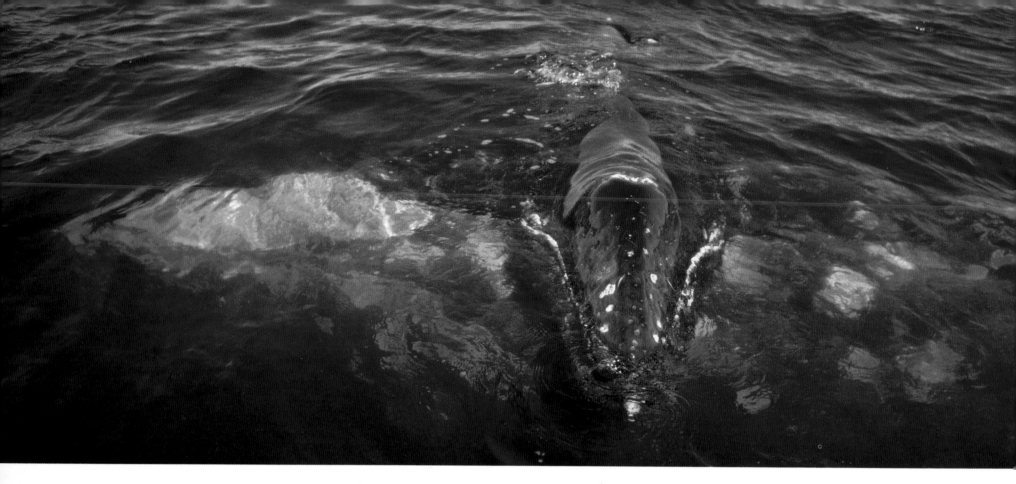

Much of the apparently 'altruistic' behaviour of cetaceans can be traced to the instinct of adults, such as this female grey whale, to protect and care for their young.

'Altruistic' behaviour

The protective behaviour that female cetaceans show towards their calves, which was so mercilessly exploited by the whalers, is well known. But these acts are in fact common to almost all mammals. Far rarer are the kinds of apparently altruistic behaviour often seen among group-living cetaceans, for example, an individual warning others of the presence of predators or attempting to swim between a whaler and a harpooned companion. At first sight such behaviour seems to contradict the notion of 'survival of the fittest' – for in evolutionary terms individuals are in direct competition with each other in the battle to pass on their genes. But

this is too simplistic an analysis. For if group living confers a benefit on all its members then it makes sense for each individual to ensure that the group survives.

Examples of altruistic acts among cetaceans are many. Among most species of cetacean a calving female will be aided by several other 'midwives' who will help the newborn to the surface to take its first breath. Similar supportive behaviour is also given to sick or injured adults – possibly as a direct reflection of the midwife instinct. This purely instinctive behaviour may explain the numerous accounts of whales and dolphins coming to the rescue of drowning humans – from the Ancient Greek legend of Arion to many modern day

reports. Again, there is the great temptation to explain such acts as those of an intelligent animal acting in a kind and selfless way. Disappointingly, it is far more likely to be an instinctive response triggered by the presence of a more or less dolphin-sized swimmer struggling in the water. And as many observers have noted, if whales were truly intelligent they would drown any human they encountered as a more fitting response to the havoc humans have wrought upon them for centuries. More direct evidence for this more cynical viewpoint is provided by the widely reported case of a captive dolphin that killed a leopard shark and then spent many hours pushing the dead fish to the surface of the pool.

Communication

In order for a large group of animals to perform any complex task cooperatively, it is essential that the individual members can communicate with each other. This does not mean that they require a language – most experts would assert that no species other than *Homo sapiens* possesses a true language – but they must have the ability to communicate a variety of messages to the other members of their social group. Chimpanzees, for example, use facial expressions, body posture and vocalizations to communicate their mood and intent. By contrast cetaceans lack the ability to modify their facial features and so their expressions are fixed and meaningless including the appealing smile of bottlenose dolphins and belugas. None the less, cetaceans have

developed their own unique means of communication suited to their aquatic lifestyle. These broadly fall into two kinds: non-vocal and vocal.

Non-vocal communication includes behaviours also used to assert rank, including breaching, water slapping and jaw clapping. Breaching is probably the most commonly observed non-vocal signal. It is particularly common among many of the baleen whales, including the grey whale and the humpback whale. By swimming powerfully upwards these massive creatures can launch themselves clear of the water to come crashing back down again. The noise this splash makes can often be heard a couple of kilometres (1 1/2 miles) away. Dolphins too are particularly fond of breaching. But while they often leap out of the water they do not always do so noisily. Only when it is their intention to communicate their presence do they deliberately twist their body to effectively 'bellyflop', slapping the water loudly enough to be heard up to a kilometre (2/3 mile) away.

Tail slapping and, at least in the case of the humpback, flipper slapping also create loud clapping sounds, and is another way in which these cetaceans can get themselves noticed – especially in rough seas. In most cases the message transmitted is a simple one, probably containing little more information than 'I am here.' Depending on the context such displays may also be a sign of aggression directed towards a rival.

Despite using these sub-vocal signs to announce their presence to others, cetaceans also communicate with each other vocally. These sounds are quite different from

those used to echolocate, and they are produced by both baleen and toothed whales. Exactly how they are produced is a mystery as cetaceans do not possess vocal chords. They do, however, possess a complex arrangement of air passages and these together with their muscular larynx are probably used to create the necessary vibrations that produce sound. Unlike land mammals underwater cetaceans cannot afford to 'waste' air by expelling it to produce sound as land animals do. Instead they recycle it, repeatedly passing the same air through their larynx.

Variously described as whistles, moans, grunts and rumbles, vocal communication probably contains more information than non-vocal water slaps, but exactly how much is debatable. In an environment where members of a social group may disappear from view when just 20 m (65 ft) away, the ability to keep in touch vocally is of obvious value. Beaked whales, for example, are often thinly distributed over vast areas of ocean and vocal communication is probably the only way these whales can locate other group members and find breeding partners. Direct observation of wild cetaceans together with studies of those kept in captivity suggest that they also use these vocalizations in a similar way to other mammals: as signs of recognition, alarm and threat.

As well as possessing the ability to echolocate, the toothed whales are generally more vocal than baleen whales. The sounds produced by those species so far studied range from low-frequency grunts and groans to high-pitched squeals and whistles. Many species produce highly characteristic sounds such as the musical fluid trilling calls of the beluga. Such is the variety of calls produced by some species that researchers have attempted to discover whether specific calls have a particular meaning. In one experiment up to 30 distinct calls of the bottlenose dolphin were recorded and then played back individually to assess the reaction. Many of the calls simply prompted a reflection of the same call back, but some resulted in the dolphins responding in a specific way such as by swimming in a highly agitated manner, producing echolocation sounds, or showing heightened curiosity about their immediate surroundings. From this it might be concluded that different calls do impart different meanings although it can be dangerous to assume too much. For while the response of a cetacean to a specific call can be recorded, it does not mean that the caller intended to communicate a particular message.

While toothed whales are generally the most vocal, baleen whales have their own repertoire of usually low-pitched vocalizations. Fin whales, for example, produce a subsonic moaning call that can probably be heard for several hundred kilometres, especially when produced in the sound fixing and ranging (SOFAR) stratum of water, a deep layer of the ocean that has the special property of transmitting sound over huge distances. Of all the baleen whales it is the humpback whale that is perhaps best known for it voice. Humpback whales – usually males – become notably vocal only during their annual migrations to warmer waters. While close to the coast,

pods of humpbacks engage in a range of social behaviour including exuberant breaching displays, body rolls and fluke slapping. They also produce a wide range of vocalizations variously described as whistles, moans, squeals and deep echoey organ-pipe sounds. The appealing 'otherworldliness' of humpback vocalizations has resulted in their intense study. As a result, it is known that individual whales produce distinctive, melodically complex songs that change from year to

year, and that discrete populations possess their own unique dialect – a feature also true of killer whales and several species of dolphin.

The great mass of information gathered has often served to confuse the understanding of these fascinating sounds. In the light of current knowledge, a more measured interpretation would be that whale vocalizations function in much the same way as the songs of birds: as territorial or sexual advertisements.

Many dolphins, including the dusky dolphin, usually congregate in large numbers. This intense sociability is believed to facilitate the location of prey and offer protection against predators that might pick off a lone dolphin more easily.

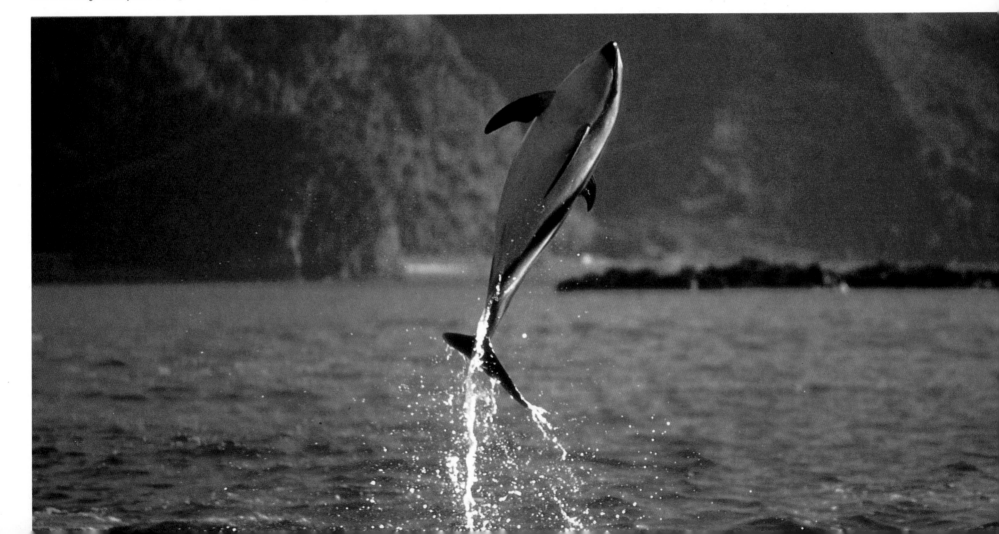

The Cycle of Life

'When whales breed
They breed with ecological
consideration:
They breed in precise relation to the
amount of food in the sea.'

Heathcote Williams, *Whale Nation*

The synchronized breaching of a humpback mother and calf characterizes their close bond.

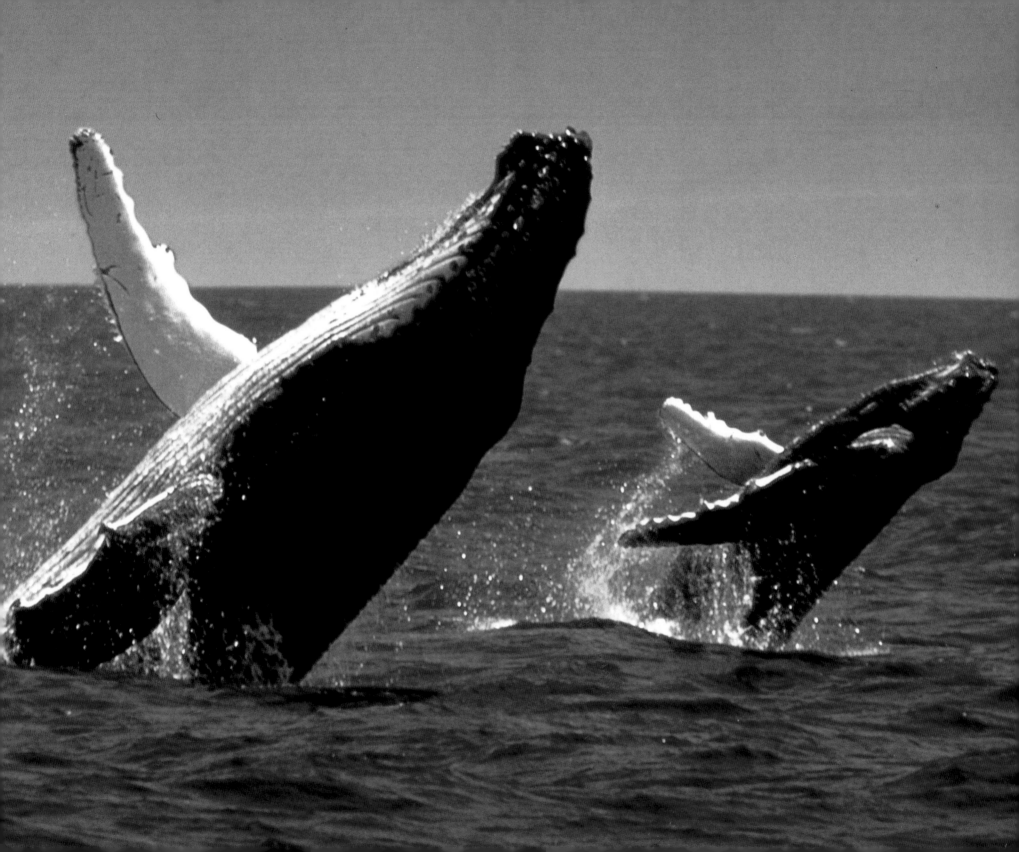

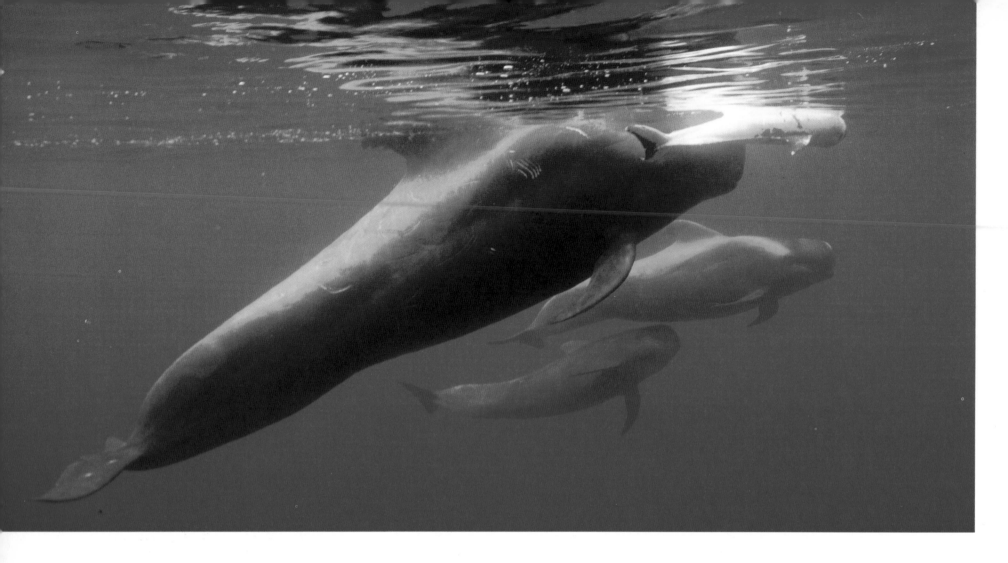

Cetaceans reproduce relatively slowly and lavish much care on their offspring. Even a dead calf is abandoned reluctantly by these short-finned pilot whales.

It is more than slightly ironical that most of what we know about the life cycle of cetaceans comes from the examination of dead whales and dolphins killed deliberately by whalers or caught accidentally in fishing nets. As a result, much of the information obtained is purely anatomical in nature and supported only by limited observations and a vast architecture of hypothesis. But while experts are still forced to guess about the courtship, mating and birth behaviour of most cetaceans, the few glimmers of insight gained from, in particular, the captive breeding of dolphins in marine aquaria, are beginning to shed some light on this most mysterious aspect of cetacean life.

Numerous problems beset the study of cetacean reproduction. Chief among these is the enormous difficulty of observing free-living whales and dolphins out on the unpredictable oceans. Even when a pod of whales or school of dolphins can be observed for any length of time, the chance of witnessing the momentary act of mating, or young being born, is but a slim one.

The task of understanding cetacean sexual behaviour is made even harder by the fact that, unlike most mammals, males and females are, with a few exceptions, almost impossible to tell apart. In none of the 78 species is there any variation in skin colour or patterning to distinguish the sexes. And in nearly all cetaceans, males and females show no external, physical sexual differences either. This is almost certainly because vision plays so small a part in their dark underwater world, compounded by the overriding need for a streamlined, aquadynamic body shape.

Sexual differentiation

When looking at cetaceans through high-powered binoculars from the deck of a ship rolling in heavy seas, it is enough of a challenge to identify the species confidently – especially the less common ones. To identify clearly the sex of an individual is usually quite impossible. But there is a handful of species that can sometimes be sexed at a distance. The males of sperm, pilot and killer whales are all significantly larger than the females. Male sperm whales, for example, typically measure 15–18 m (50–60 ft) in length while the females seldom exceed 12 m (40 ft). The sex of long-finned pilot whales can also be determined by the shape of the dorsal fin. Males have more bulbous and hooked dorsal fins while the fins of females are more upright – the reverse is true for killer whales.

Some cetaceans also show tooth development that differs between the sexes. The teeth of adult female beaked whales, for example, are normally absent or invisible, whereas those of adult males often protrude, and in some cases resemble the tusks of wild boar. But this sexual difference is not always easy to identify at sea. Instantly recognizable, however, are the tusks of narwhals. Once referred to as 'sea unicorns', the males of this species of cetacean have two teeth in the upper jaw, one of which – almost always the left one – erupts and develops into a 2-metre- (7-ft-) long tusk. Occasionally, both teeth erupt producing a double tusk. Even this most visible badge of sexuality is not always reliable, as about 3 per cent of females also develop tusks and there is even one known case of a female with two tusks.

With these few species excepted, the sex of an individual can only be determined after it has died. In both males and females all the genitalia are hidden, to preserve the smooth external lines that make these aquatic mammals such efficient swimmers. In females there is a genital slit quite close to the anus, whereas in males the slit is almost halfway between the anus and navel. Females also have two barely visible mammary slits either side of the genital opening. Internally whales and dolphins have sexual organs similar to those of most mammals, only proportionally larger: the testes of right whales can weigh over a tonne while the penis of sperm whales often exceeds 3 m (10 ft) in length.

Determining age

As well as the difficulties encountered in identifying the sex of individual whales and dolphins, estimating their

age is also tricky. This has presented another barrier to the understanding of the cetacean life cycle. It has also limited scientists' ability to estimate the effects of whaling on particular species, as the age of sexual maturity, the age at which females first give birth and the period over which they remain fertile, are all key to a species' ability to withstand the losses that occur both naturally and through the actions of humans.

Fortunately, in recent years a good deal of progress has been made in this area. In toothed whales it may be possible to determine the age of a particular individual by examining the alternate light and dark layers of dentine visible in the teeth. By slicing a section across a tooth the growth layers – like those of a tree – are revealed and can be counted to discover the animal's age. This method has already proved an accurate way to age seals, although, so far, only a couple of species of cetacean have been studied in detail. Despite the possibility that the number of growth rings produced each year may vary between species, it seems likely that it gives a fair estimation of age. The age of baleen whales obviously cannot be calculated from their teeth as they do not have any. But the horny plug found in the ear canal of baleen whales both sheds cells and secretes wax, creating dark and light bands that can be sectioned and counted in the same way as the dentine layers of teeth, although there is a little more uncertainty about the rate at which these layers form. Tests have been carried out on blue, fin, humpback and Bryde's whales and, while it is now generally agreed that each

lamination corresponds to one year, there remain confusing examples like that of a humpback whale that was marked when a year old and then, when killed at the age of six, was shown to have an ear plug bearing 12 laminations.

With the ability to judge the age of cetaceans accurately it has been discovered that they are similar to many other mammals in that they become sexually mature at a particular size – usually before they are physically mature – rather than when they are of a certain age. For example, the fin whale, which is typical of most larger rorquals, is often sexually mature when around 20 m (65 ft) in length and 6–7 years old. But it does not reach physical maturity, when males may be 10 per cent larger, until it is between 15 and 20 years old. Similarly, male sperm whales are sexually mature when about 8–10 m (25–33 ft) long and about 20 years old, but are not fully grown for another 10 or 15 years. And male sperm whales often do not breed for several years after they are sexually mature as they need to be large enough to compete with other males to gain access to females.

As well as the age at which they can breed and give birth, the reproductive history of female cetaceans can also be gauged from an analysis of their ovaries. With every egg produced, flowery growths called follicles, erupt in the ovaries and, instead of disappearing as they do in most other mammals, they remain for the rest of the animal's life. By counting these follicles it is possible to determine at least how many times the

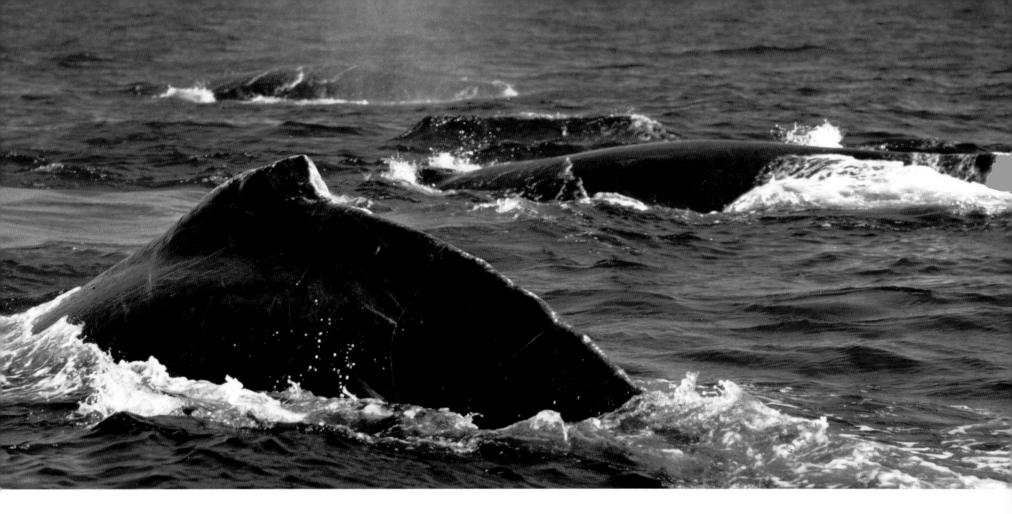

female has ovulated – although it is impossible to say how many of these ovulations resulted in pregnancy.

Estimating the average lifespan of the many species of cetacean is difficult when the information derives mainly from animals whose lives have been ended 'artificially' by a whaler's harpoon. But by examining the ages of the huge numbers of large whales caught this way, together with the innumerable dolphins caught in the purse seine nets of tuna fishermen, a reasonably accurate picture can be obtained. Cetaceans do not live for as long as had previously been thought for such large animals. While elephants regularly achieve the

Biblical three score years and ten, the larger baleen whales appear to live for only 30 or 40 years. Among the toothed whales, bottlenose dolphins seldom live longer than about 25 years, while sperm whales live a little over 50. An interesting fact to emerge from these studies, however, is that some female cetaceans often live beyond the menopause – the age at which they stop ovulating. Although common in elephants and humans, this is a relatively rare occurrence in the animal kingdom as there is little obvious value to a species for its individual members to live beyond the point at which they can produce offspring.

The ability to identify the age and sex of a cetacean is vital to the study of its social and sexual behaviour. In some cases, an individual may have a distinguishing feature, such as this humpback's damaged fin.

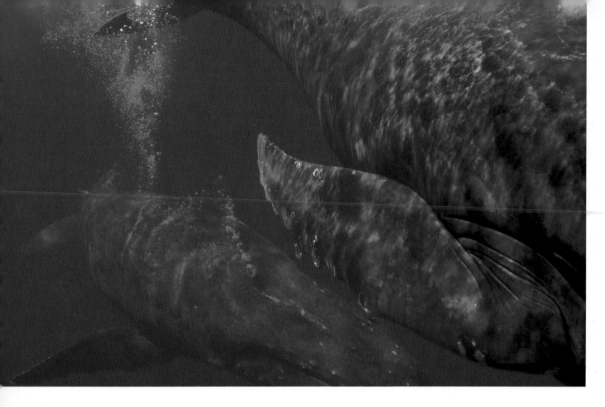

Cetacean courtship behaviour has rarely been witnessed, but male humpbacks are believed to court females by producing streams of bubbles in a manner similar to the bubble-netting they use to catch fish.

Right: Although typically mammalian in form, the sexual organs of cetaceans are usually hidden within the body to preserve its streamlined shape.

female humpbacks producing two calves every three years and female grey whales giving birth almost every year. A single species of baleen whale, Bryde's whale, which inhabits warm waters all year, and all the toothed whales follow no such pattern and appear able to breed at any time of the year. Their generally longer gestation and lactation periods result in a slightly lower reproductive rate – sperm whales breed only every four years or so. Their breeding cycle also appears to lengthen with age. Young short-finned pilot whales may lactate for 2–6 years whereas older females may lactate for up to 15 years.

Breeding seasons and cycles

The timing and length of a species' reproductive cycle depends both on biological factors – such as the frequency of ovulation, the gestation period and the age at which young are weaned – together with environmental factors – such as the availability of food for both the pregnant or nursing mother and the newborn. Most baleen whales, for example, breed only in the winter after they have migrated to warmer, sub-tropical waters. Fin whales that feed in Antarctic waters usually breed between April and August, while those that inhabit the northern hemisphere breed in November. This annual cycle is mirrored in the gestation and lactation periods, which means that, on average, females breed every two or three years. Humpback and grey whales, however, both appear able to conceive while still lactating and so are able to reproduce more rapidly, with

Courtship and mating

When it is difficult even to identify the age or sex of living whales and dolphins, the task of recognizing sexually related behaviour is awesomely hard. But, as with the study of cetacean social behaviour, scientists have looked for, and found, patterns of sexual behaviour similar to those of terrestrial mammals. Such studies

require tremendous patience and meticulous observational skills, together with some inspired guesswork. In many respects cetaceans are no different from any other animals; in order to mate successfully sexually mature adults must be able to find each other, confirm a readiness to breed and then obtain the opportunity to mate. For land mammals sight and smell are the senses most frequently used to locate and identify the condition of breeding partners. But cetaceans must use other means. It has been suggested that males may be able to taste the sexual chemicals (pheromones) produced by females receptive to mating, but this theory hasn't been proved. Sound is known to be the chief way in which cetaceans communicate with each other, so it is not impossible that some of their vocalizations are in fact mating calls, but again, this remains conjecture.

Cetacean courtship and mating has only rarely been seen in free-living species, so most of what is known has come from the studies of captive species. The sociability of cetaceans is well known and it appears that much of their behaviour has a sexual element. Fluke slapping, high speed chases, nuzzling and body rubbing could all be part of courtship behaviour as all have been seen prior to mating by mature adults and attempted mating by immature males. In bottlenose dolphins such courtship behaviour, if successful, is followed by the male swimming beneath the female and mating with her, their bodies at right angles to each other. As in many animals, mating is swift, lasting just a few

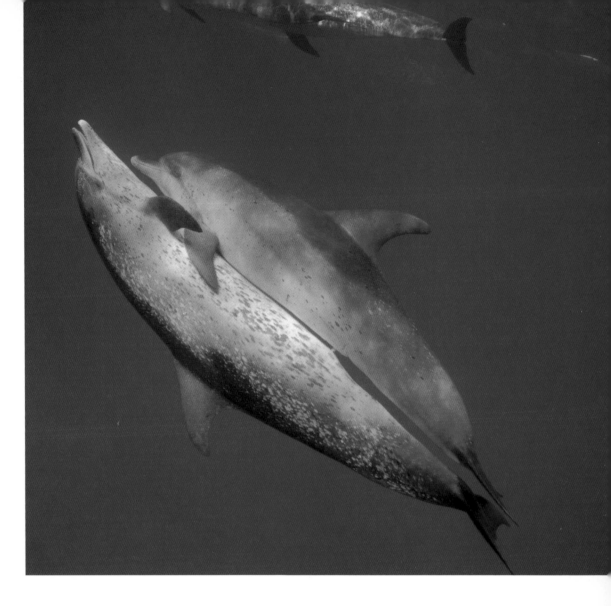

seconds. In larger species of whale, side-by-side coupling appears to be more normal. But there have been observations of humpback whales swimming directly towards each other and then rising out of the water belly to belly in what could be a far more spectacular copulatory technique. In most species mating is repeated several times and both males and females generally mate with several partners.

To mate, the male, such as this Atlantic spotted dolphin, usually swims up from beneath the female so that they can couple belly to belly. Copulation often lasts just a few seconds but is often repeated.

Pregnancy and birth

After fertilization the female's pregnancy is similar to that of other mammals. In baleen whales gestation lasts for between 10 and 12 months. Toothed whales display more variable terms, ranging from 9 to 18 months. In the larger whales the growth rate of the foetus is quite incredible and is easily the fastest of any group of mammals. In the last few weeks prior to birth, a foetal blue whale increases in weight by 100 kg (220 lb) a day – a rate of growth up to a 1000 times greater than that of a human foetus. At birth, a blue whale calf may be 8 m (26 ft) in length and weigh over 2 tonnes. Cetaceans are unusual in that the size of the offspring at birth is determined not by variations in the length of the pregnancy – as is the case in most mammals – but by the differential rate of foetal growth.

From the very few observations of baleen whale births, it appears that, as with most mammals, the young are born head first. Toothed whales bred in captivity have all produced their offspring tail first. Such 'breech' births appear not to present any problems as

the flukes are soft and folded. The initial stages of birth may be quite slow, with the flukes of the partially emerged offspring protruding for an hour or more. But once the final stage is reached the young emerge rapidly. This is clearly essential as once the umbilical cord is ruptured the whale calf must be quickly transported to the surface to take its first breath.

Cetaceans typically give birth near the surface. The grey whale, for example, exploits the warm shallow lagoons on the coast of California. But the lack of oxygen in the lungs of young cetaceans, together with their lack of blubber, means that they are not buoyant - they sink rather than float. As a result the mother, and sometimes attendant 'midwives', immediately nudges the newborn to the surface for its first breath. Apart from its lack of blubber, the young cetacean, or calf, is a well-developed, perfect replica of its parents. Because the young are born so physically developed, multiple births are very rare, and although there is one record of killer whale twins surviving, twins or triplets usually do not.

Soon after the birth the calf is fed by the mother close to the surface, so it can breathe regularly. Because cetaceans do not have flexible lips, the calf cannot suckle in the same way as terrestrial mammals. Instead, the calf grips the mother's now protruding nipple between its tongue and the roof of its mouth and she uses the muscles around her mammary glands to squirt the rich milk directly into its mouth. For the next few days at least, the calf stays close to its mother, consuming, in the case of the larger baleen whales, over

After a gestation period of over a year, the female grey whale gives birth to a calf weighing 500 kg (1100 lb) and measuring over four and a half metres (15 ft) long.

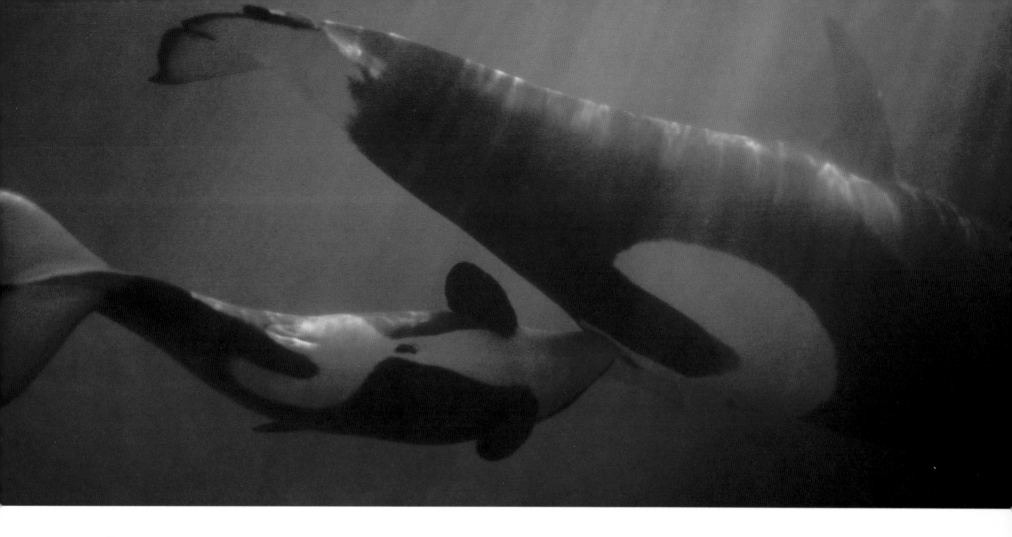

100 litres (22 gallons) – and perhaps as much as 600 litres (132 gallons) – of milk a day. In species that live in tight-knit social groups, the calf may also feed from other, often closely related, females. The calves of most baleen whales suckle for 5–7 months – although humpback calves suckle for up to 11 and grey whales 12 – while the calves of toothed whales typically nurse for up to two years. Cetacean milk is remarkably rich, containing between 15 and 50 per cent fat – compared with 3–5 per cent in cow's milk – and the newborn grows extremely quickly, increasing its weight by up to

80 kg (175 lb) a day and doubling its birth weight in a week. Because of this, a two-year-old that has just been weaned may be heavier than a five-year-old that has been feeding itself for a few years. A two-year-old blue whale, for example, will have doubled its birth weight and measure over 15 m (49 ft) long.

Although the young of toothed whales typically nurse for longer, all cetacean young begin to feed themselves at the age of a year or so. The young are born without teeth or baleen but in most species the teeth or baleen plates appear within a few months.

Whale calves, like this young killer whale, obtain their mother's rich milk from nipples that are erected from mammary slits on either side of the genital opening.

Masters of the Ocean

'Oh, the rare old whale, mid storm
 and gale
In his ocean home will be
A giant in might, where might is right,
And king of the boundless sea.'

Traditional whale song

Despite being air-breathing mammals, whales and dolphins have achieved true mastery of their aquatic habitat.

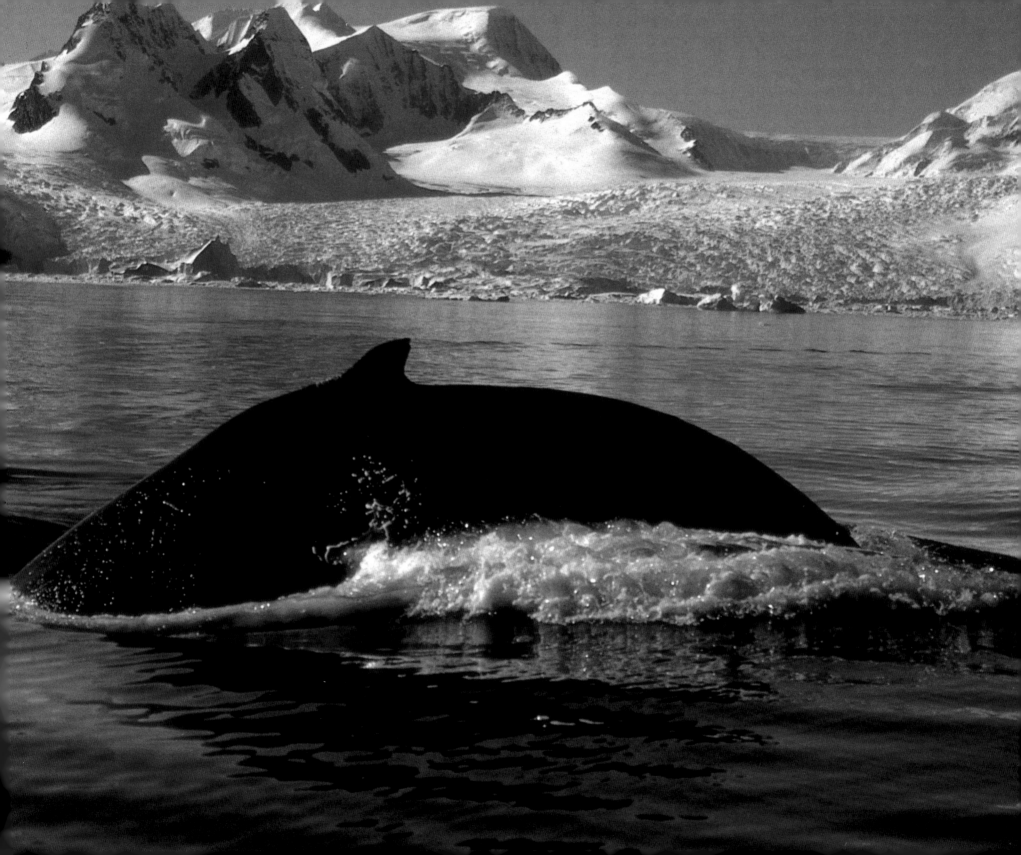

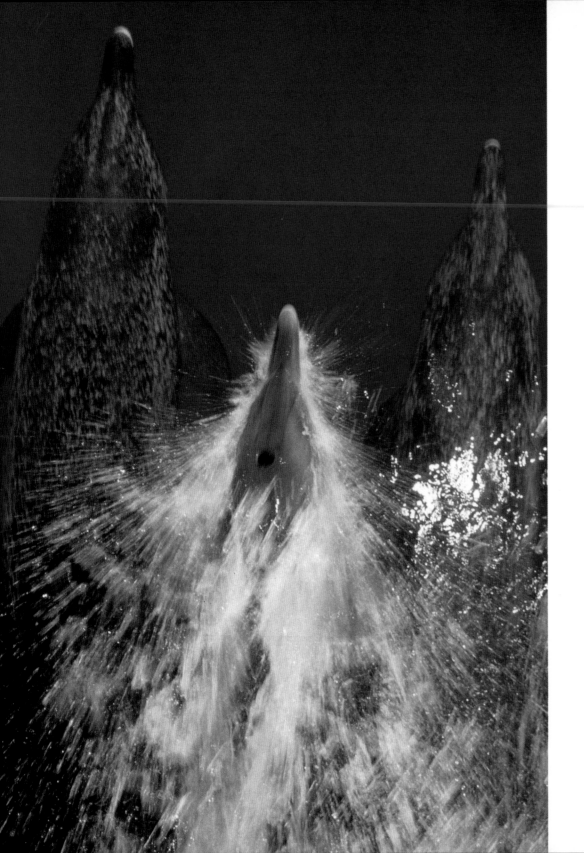

Perhaps part of our fascination for whales and dolphins derives from the admiration of specialism. Although every species has evolved to exploit its environment efficiently, those that have become most highly adapted – the true specialists – are often the ones that are most fascinating. Humankind has long marvelled at the lithe power of the big cats, envied the aerial ability of birds and exploited the speed and stamina of horses. So, too, it is difficult not to be in awe of the aquatic adaptations of whales and dolphins. Of the myriad creatures that inhabit the world of water, whales and dolphins are undoubtedly among the most accomplished – a remarkably impressive feat when it is remembered that their mammalian inheritance still requires them to breathe air. For not only are cetaceans the largest of the oceans' inhabitants, they also rank among the fastest swimmers, the deepest divers and the greatest travellers.

In the swim

During their evolution from four-legged land animals to fluked and finned masters of the ocean, cetaceans developed hairless, smooth-skinned and streamlined bodies perfectly suited to moving through the relatively dense medium of water. They achieved this transformation so efficiently that some species, notably dolphins, can swim with ease at speeds of up to 55 kmh (34 mph), and even the more massive of the baleen whales can attain 30 kmh (19 mph) for a short period. The speed and agility of dolphins has been recognized ever since humans first ventured out on to the sea, but a clearer appreciation of

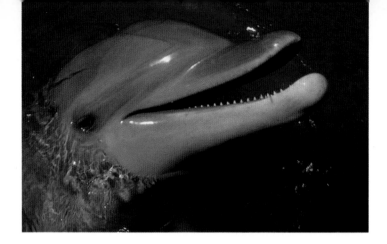

their ability only developed as a result of research carried out in the late 1940s. As part of an experiment to learn more about how dolphins swim, researchers built a model dolphin and tested its aquadynamic properties in a laboratory. The results of these experiments suggested that dolphins actually swim faster than the theoretical maximum predicted by the model. Although clearly a ridiculous conclusion, it did serve to prompt further study of these remarkable creatures. Eventually, some 15 years later, a clearer picture emerged.

Although cetaceans possess the low-drag, tear-drop shape of a typical fish, they swim quite differently. Most fish swim by flexing the body sinuously and sweeping the tail fin through the water from side to side. Whales and dolphins, on the other hand, power their way through the water by thrusting their flukes up and down. The flukes are themselves shaped like the wing of an aircraft – thick at the front and thin at the rear. Forward motion is generated largely on each upstroke, the power stroke, which drives the water from the upper surface of the flukes to their lower surface. This action produces a vortex behind the tail and an area of low pressure beneath the flukes resulting in the flow of water over the body. This results in the cetacean being propelled forwards and downwards. On the downward, or recovery, stroke this process continues while the natural buoyancy of the head causes the front of the body to rise. Two blocks of massively powerful muscles on either side of the spine drive the flukes, but the whole of the body also flexes as part of the swimming action.

But cetaceans do not rely on pure muscle power alone to drive themselves through the water at speed. Their highly 'slippery' bodies reduce the friction – drag – caused by their passage through the water. The skin of a dolphin, for example, has a texture rather like rubber. Not only does this present a smooth surface over which the water can flow easily, but some scientists also believe that a dolphin can actually flex its skin while swimming to subtly alter its body profile and minimize drag still further. It is also known that the skin of cetaceans sheds cells rapidly. Studies on a captive dolphin found that the thin outer layer of skin cells was shed 12 time a day. Furthermore, the cells shed contained tiny droplets of oil. It is thus possible that this rapid loss of cells and oil acts as a lubricant, reducing friction between the dolphin and the water still further.

Below the waves

The one aquatic adaptation that cetaceans have failed to achieve is the ability to extract oxygen directly from the water. As a consequence, they are inextricably tied to the surface in order to breathe. Despite this apparent handicap, the diving ability of all cetaceans is impressive and that of some species is quite incredible.

Key to the remarkable ease with which cetaceans, like the bottlenose dolphin, swim, is their smooth, flexible skin.

Opposite: Dolphins, like the Atlantic spotted, swim at remarkably high speeds, thrusting themselves through the water by sweeping their tail flukes up and down through the water.

Opposite: Sperm whales can dive to great depths and remain underwater for between 90 and a breathtaking 120 minutes.

As part of their adaptation to an aquatic environment, the nostrils of cetaceans are located on the top of the head. These 'blowholes', single in toothed whales (top) and double in baleen whales (bottom), are closed while underwater and opened at the surface.

It might be imagined that the huge size of many whales plays a part in their ability to breathe more slowly and hold their breath for long periods. But, interestingly, those whales that dive deepest actually have smaller lungs in proportion to their body size than those that dive less deeply – and the ability to 'hold a breath' plays no part in their diving ability. This is because the pressure at the great depths to which many whales dive compresses any air present in the lungs to a fraction of its volume. Furthermore, below 100 m (330 ft) the lungs collapse completely anyway. So, instead of relying on stored breath, cetaceans have developed the ability to store oxygen in their bloodstream and muscles – where it is most useful. Whales' blood is particularly rich in haemoglobin – the red pigment that stores oxygen. Even for their great size, they possess a disproportionate amount of blood. Similarly, their large muscles contain a high proportion of myoglobin – the muscle protein that stores oxygen. These adaptations are further enhanced by the ability of cetaceans to slow their heartbeat to well below half the normal rate, and to deprive some parts of their body of oxygen while diving. They are also better able than most terrestrial mammals to metabolize anaerobically – to produce energy without oxygen.

The combined effect of these adaptations is largely to free whales from the limitations of life at the surface, and permit them to pursue their prey far below the waves. In the past, however, the depths they plumbed could only be guessed from the time they spent below the surface, and by the discovery of fresh bottom-living fish in the stomachs of whales caught by whalers in seas of known depth. Such information was further supported by the occasional discovery of a whale entangled in deep sea cables.

More recently, however, the use of sonar and the tagging of whales with radio transmitters has made it possible to obtain a much clearer picture of their true diving abilities. Baleen whales generally do not dive much deeper than about 100 m (330 ft). The longest dive ever recorded for a baleen whale was timed at around 40 minutes. After a dive, the explosive exhalation of spent air, water vapour, seawater and, possibly, small droplets of oil – known as 'the blow' – can often be spotted at great distance. In some species the size and shape of the blow is quite distinctive. The blow of a blue whale, for example, is visible as a tall conical column rising some 9 m (30 ft) into the air.

Surface breaths can be taken in less than a second by some dolphins and in two or three seconds by the larger baleen whales. Cetaceans normally breathe while on the move but, again, the sperm whale is unusual in that it often remains motionless on the surface as it takes as many as 50 breaths before submerging again.

The deepest divers are those toothed whales that feed on squid: the beaked and sperm whales. Sperm whales typically feed down to around 500 m (1640 ft), but occasionally they descend to depths of well over 1000 m (3280 ft) and it is thought that they may possibly dive as deep as 3000 m (9840 ft).

Spermaceti

The sperm whale is undoubtedly the champion diver among cetaceans. It is also one of strangest and most mysterious of the great whales. The structure of its large blunt head is quite different from that of any other animal. At it centre lies a vast mass of tissue rich in a waxy substance called spermaceti. The function of this store of wax – which in an adult whale may weigh over 2 tonnes – has long puzzled scientists.

It is possible that the spermaceti is used in connection with echolocation, but there is another, if somewhat controversial, theory linking this massive reservoir to the sperm whale's diving prowess. Like humans, whales are naturally buoyant. To dive, they must, therefore, use energy to drive themselves down through the water. The deeper the dive the more effort they must expend to resist the tendency to float back to the surface. For the sperm whale to force its great bulk down to the tremendous depths at which it feeds must require a lot of energy. Any adaptation that reduces this energy demand would clearly be of great benefit. Although spermaceti is liquid at the whale's normal body temperature, it has been discovered that when cool, it not only solidifies but it also becomes more dense – a process enhanced by increased pressure. It has been suggested, therefore, that the whale might deliberately cool its spermaceti – perhaps by drawing in seawater through its nasal passages – to reduce its buoyancy, and facilitate its ability to dive.

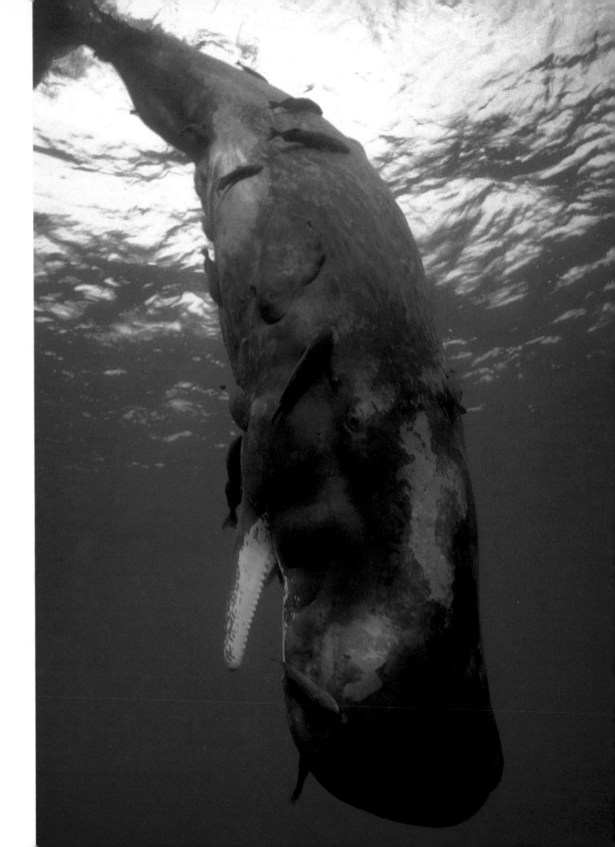

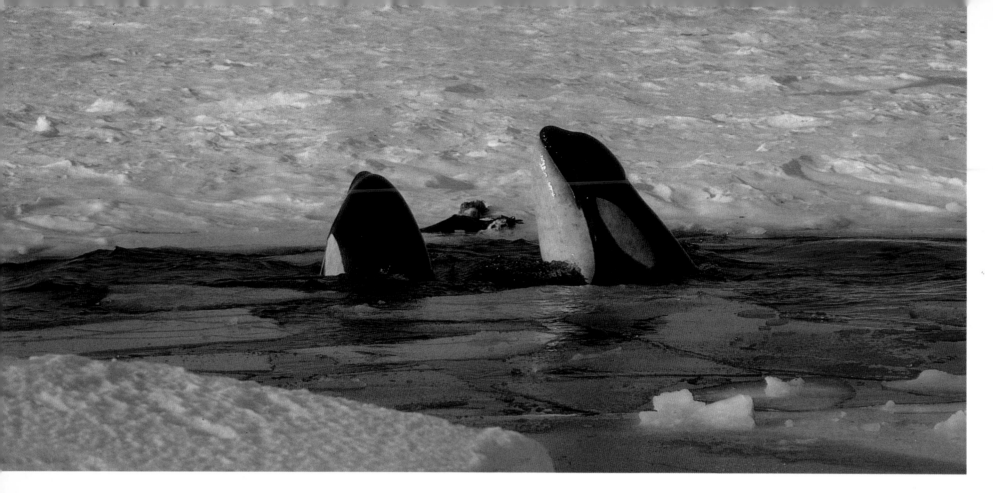

Distribution and migration

Killer whales are one of the most wide-ranging mammals on Earth with a distribution that extends from both poles to the Equator and encompasses every major open ocean and sea.

Cetaceans are found in almost every large body of open water throughout the world. But while some species are distributed almost globally, others live in quite restricted areas. River dolphins have become so specialized that they seldom stray far from certain stretches of their home river. Similarly, many porpoises inhabit the waters along relatively limited lengths of coastline. Many species, however, have far wider ranges. Some, such as the hourglass dolphin, have a circumpolar distribution while others, such as the pantropical spotted dolphin, occur right around the Equator. A few species also have populations split between the hemispheres, both north-

south and east-west. In some cases, such as the northern and southern right whales, where there is no intermixing between the populations, quite separate subspecies have developed.

With the exception of minke, Bryde's and pygmy right whales, all baleen whales undertake regular seasonal migrations from their feeding areas to their breeding grounds. This behaviour probably derives from the fact that, although they have evolved the ability to exploit the vast zooplankton resources of cold Arctic and Antarctic waters, their young need to be born in the warm – but food-scarce – waters nearer the Equator. The length of these migrations means that many of these

huge whales feed for only a few months a year, during which time they must lay down huge reserves of fat in the form of blubber to sustain them during the months spent travelling to and from the breeding grounds.

The urge to migrate, which is instinctive, is probably triggered by the change in day length – as it is in other migratory animals. Whole populations do not set off *en masse*, however. Usually it is the pregnant females and females with calves that start out first and, as a result, for many weeks the population may be strung out over a distance of thousands of kilometres between summer and winter habitats. Although the chief purpose of these migrations is for females to give birth, the males also migrate, as mating takes place shortly after the young are born.

For some species, migration to specific areas also enables different populations to interbreed. But this is not true for those species that inhabit polar regions. Because the northern and southern winters are six months out of phase, these whales never meet, despite the fact that they may share the same breeding grounds.

Toothed whales are far less migratory than baleen whales. Only in Arctic species, such as the beluga, where the formation of ice drives the whales south, do whole populations migrate together. In all other cases toothed

whales make far less predictable and more opportunistic movements – such as to exploit temporary concentrations of food. Again, it is the enigmatic sperm whale that is most unusual in its behaviour. For while females and young stay in the same relatively warm waters all year round the males do not remain with them. In the spring and summer 'bachelor' pods move north into polar waters. Exactly why they do this remains unclear, as the waters the males migrate to do not appear to offer a greater amount of food than those they leave behind.

Left: Most baleen whales, including the humpback, migrate, travelling great distances between feeding and breeding grounds.

Toothed whales, such as the bottlenose dolphin, generally live in one area all year round. They often demonstrate an intimate knowledge of their locality and the resources it offers.

Stranding

For many hundreds of years the sight of a live whale beached on the shore was almost certainly regarded by the local human population as a gift from the gods: a large whale could provide a small village with enough food and oil for many weeks. Today, however, the sight of stranded whales is more likely to evoke feelings of pity than joy, and great effort is often expended trying to help the hapless animals back into the sea.

There are three basic kinds of stranding, each of which is more or less explicable. The beaching of dead cetaceans is the most easily understood. When alive many cetaceans are naturally buoyant and when they die they also float. Most dead whales are probably eaten by scavengers or decompose and eventually sink. But a few will be carried on ocean currents to be washed ashore. The live stranding of individual whales is equally easy to comprehend. In most cases it is probably due to the animal being old or sick and either losing its bearings or being unable swim strongly enough to resist onshore currents.

Although there are no records of baleen whales mass stranding, individual baleen whales, such as this pygmy right whale, do strand periodically.

Mass stranding of live cetaceans are much more mysterious and disturbing occurrences. And as if the sight of a large school of apparently healthy whales drowning in the shallows is not tragic enough, as many would-be helpers have discovered, attempts to drive the cetaceans back out to sea, if temporarily successful, are often rewarded by the animals returning to strand themselves again a little further up the shore. It is perhaps the seeming 'wilfulness' behind strandings that has prompted scientists to try to find an explanation.

Although strandings attract a lot of publicity, only a few thousand cetaceans at most die in this way each year. What is interesting, however, is the fact that certain species strand more frequently than others. In fact, about ten of the 80 or so species of whale and dolphin account for by far the majority of these mysterious deaths.

Although there is no strict numerical definition of a 'mass' stranding, it stands to reason that it can only happen to species that live in reasonably large social groups. So it is perhaps not so surprising to discover that there are no records of baleen whales stranding *en masse*. Furthermore, while these events only affect toothed whales, species that are chiefly coastal – such as porpoises – appear quite immune. Species that strand frequently include the sperm whale, pilot whales, a few beaked whales and several species of oceanic dolphin.

From all the available evidence many different conclusions have been drawn. It has been suggested that cetaceans strand themselves deliberately – a view apparently supported by the deliberate way in which

individuals refloated by human helpers immediately attempt to beach themselves again – but for what reason can only be guessed. One hypothesis is that the members of a pod follow a sick or dying individual into shallow water and simply refuse to leave their companion.

A less romantic theory is that parasitic infection – to which whales are particularly prone – may interfere with their hearing and so affect their ability to communicate or navigate using sound. In a similar vein, it is conceivable that the cetaceans' sonar becomes confused or is interfered with in some other way – perhaps by noise produced by the engines and sonar of shipping.

But perhaps the most plausible explanation available at present relates to another of the special senses used by cetaceans to navigate: magnetism. Studies of migrating whales have shown them to possess a sense that allows them to navigate using the Earth's magnetic contours. And analysis of common sites of mass strandings seems to suggest that they regularly occur where there is a perpendicular intersection between the coast and the magnetic lines of force. If this is indeed the case, then it would neatly explain why otherwise perfectly healthy animals seem to beach themselves so determinedly. It would also explain why coastal species do not strand, for these species are unlikely to rely so heavily on this sense as they seldom travel far and, even if they did, they would have grown up with an understanding of the magnetic vagaries of their locality.

Both the northern and southern populations of long-finned pilot whales are prone to mass stranding, perhaps as a result of magnetic anomalies that confuse their navigational sense.

Cetaceans and Humans

'The great, intelligent eyes stared back
into his; was it pure imagination, or did
an almost human sense of fun also lurk in
their depths? Why were these graceful sea-
beasts so fond of man, to whom they
owed so little. It made one feel that the
human race was worth something after all,
if it could inspire such unselfish devotion.'

Arthur C. Clarke, *The Deep Range*

Diving with cetaceans provides a profoundly enjoyable
and harmless way for humans to interact with these
wonderful creatures.

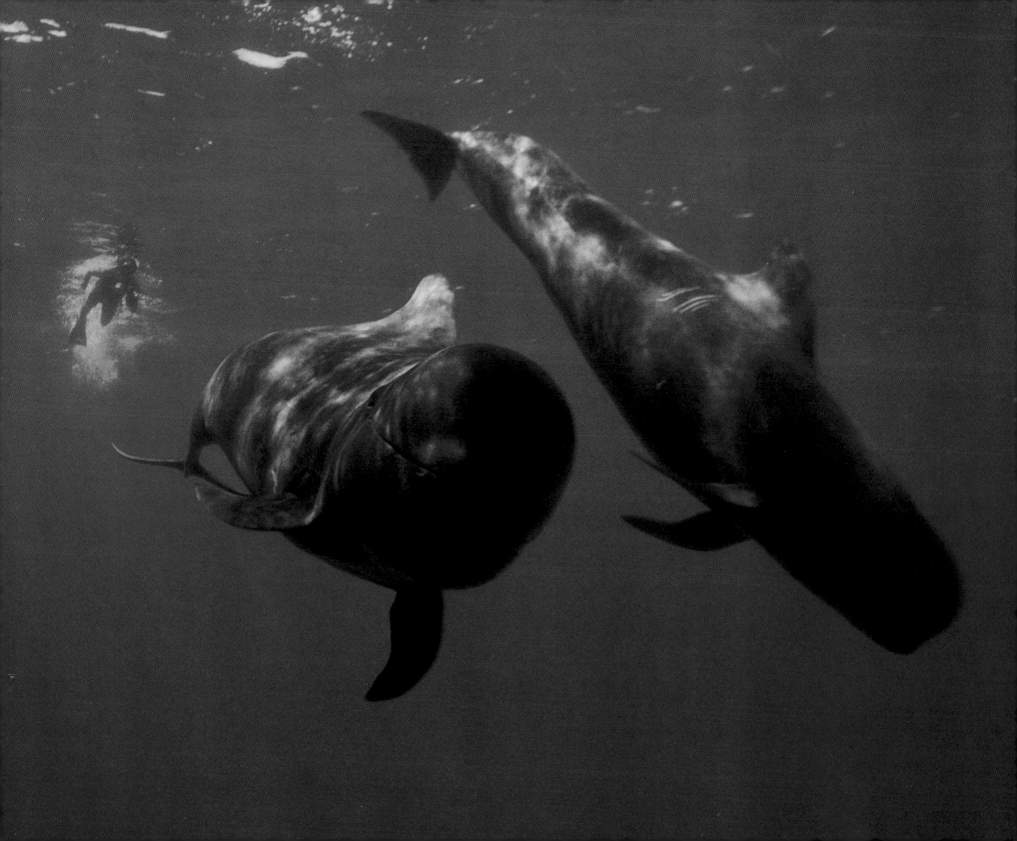

WHALES AND DOLPHINS

For thousands of years the relationship between humans and cetaceans has principally been one of hunter and the hunted. For although the sheer size and agility of some species has in some observers also prompted a sense of respectful awe, whales and dolphins have been seen chiefly as a resource to be mercilessly exploited at every opportunity. In the last few decades, however, humanity's attitude to these mysterious and marvellous creatures has undergone a sea change. Public awareness of the terrible impact of modern whaling on many cetacean species, together with widespread rejection of inhumane whaling practices, has resulted in a worldwide moratorium on this mass slaughter. Furthermore, alongside the recent developments in the study of wild

cetaceans, a thriving 'whale watching' industry has grown up that has served to engender even greater empathy between humans and cetaceans by bringing ordinary people into close contact with these marine mammals.

A terrible slaughter

Evidence of the human exploitation of whales reaches back over 6000 years in Alaska and about 4000 years in Norway. The first encounters between Stone Age peoples and the great whales would probably have been the discovery of live strandings. To the people inhabiting harsh northern lands, a large whale would have been seen as a bountiful gift, providing not only huge amounts of meat, but many useful by-products including skin, bone and oil. But the abundance of great whales in the Arctic, especially slow moving, coastal species, such as the bowhead and the northern right whale, would soon have tempted the more adventurous members of these early hunter-gatherer societies to pursue them actively.

Although such subsistence hunting would undoubtedly have had an effect on local whale numbers, it was not until the twelfth century that the whaling techniques developed by the Basques, in the Bay of Biscay, became sophisticated enough to have a serious impact. The right whale was the first to suffer, due to its coastal habits and slow speed. Swimming at around 9 kmh (6 mph), it was easy to hunt, and due to its high oil content it floated when dead and so was easy to retrieve.

Over the next 500 years whaling became steadily

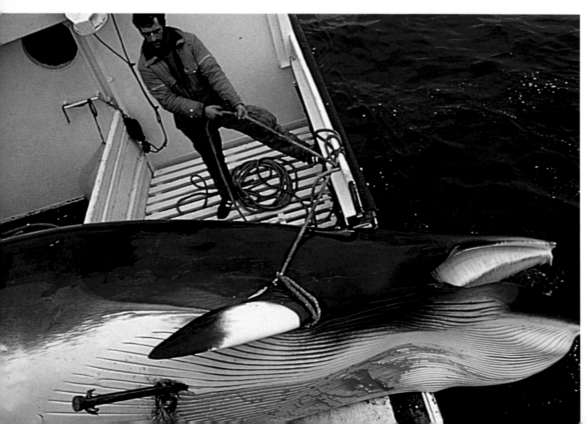

As successive populations of great whale crashed, due to merciless exploitation, the minke whale, smallest of the rorquals, became the whalers' target.

more efficient and widespread. But true modern whaling began in 1868 with the invention, by the Norwegian Svend Foyn, of the bow-mounted explosive grenade harpoon. Fired from a cannon, mounted on the prow of steam-powered vessels, this weapon allowed the faster-swimming species of whale to be hunted, and the number of kills per voyage rose dramatically. Perhaps more significantly, whaling spread in 1904 from the Arctic to the Antarctic – the southern stronghold of blue, fin and sei whales.

The slaughter of southern ocean blue whales reached a peak in the 1930–31 season – when over 30,000 were caught – and was followed by an almost immediate population crash. The industry was slow to learn, however, and it was not until after the Second World War that it began to consider the future and the possibility that whaling was becoming a victim of its own success. As a result, in 1946 the International Whaling Commission (IWC) was established and full protection was offered to right, grey and Antarctic humpback whales. Despite this, the blue whale population crashed again in the 1950s, followed by the fin whale in the early 1960s and the sei whale shortly after. Only in the 1970s – with the whalers pursuing the minke whale – did the tide begin to turn and the IWC begin to adopt a more conservationist attitude. In 1972 the United Nations called for a ten-year ban on commercial whaling – rejected by the IWC – and the United States banned the taking or importing of marine mammals except by indigenous populations. More

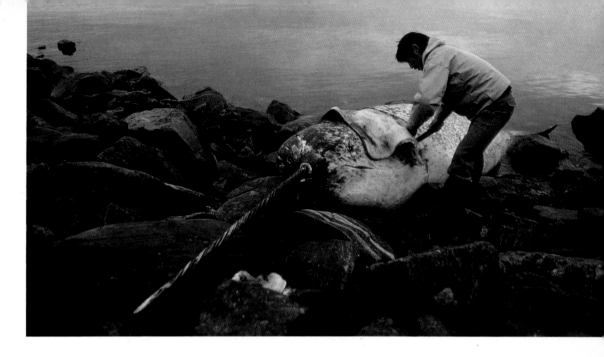

significantly, in 1979, a moratorium on almost all factory-ship whaling was established, and a 10 million km^2 whale sanctuary in the Indian Ocean was established. Then an indefinite moratorium on commercial whaling was called seven years later. However, this ban contains both an exception and a loophole. The exception allows for the 'subsistence' hunting of cetaceans by indigenous populations – despite the fact that many indigenous populations don't use traditional methods and often pursue the most endangered species; the loophole permits 'scientific whaling', purportedly to assess the population size and structure of specific whale stocks. As a result, some countries have continued whaling despite the moratorium. Since the ban, however, public opinion has, in many countries, turned even further against the slaughter. The truce remains fragile and conservationists argue that the role of protector needs to be transferred to a different authority, one that doesn't have commercial links to the whaling industry.

Despite the WIC moratorium on whaling, certain indigenous peoples, such as the Inuk, are permitted to kill whales for subsistence or cultural reasons.

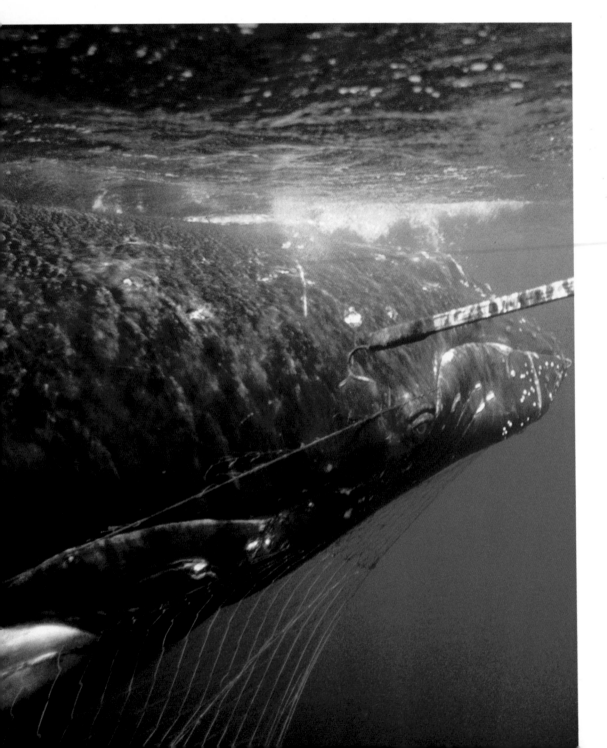

Nets of death

The deliberate havoc wrought upon many species of great whale by the whaling industry is a cause for great remorse, but the accidental killing of thousands of smaller cetaceans, usually dolphins, by the fishing industry is clearly even more tragic. To a greater or lesser degree all forms of commercial fishing take their toll on cetaceans. Among the worst, however, is drift netting because of the scale of the operation. Often referred to as 'walls of death' these nets hang vertically in the water and extend over hundreds of kilometres, indiscriminately catching any living creature that blunders in to them.

Of particular threat to dolphins are the purse-seine nets of the tuna fishing industry. For some reason, tuna often congregate with large numbers of dolphin – and the fishing fleets often use the dolphins as markers for their prey. Once a large school of dolphins has been located the nets are played out and then a cable at the base of the net is drawn in, closing the net like a purse and trapping both fish and dolphins. During the 1960s and 1970s hundreds of thousands – perhaps even millions – of dolphins perished. Attempts have been made to reduce the mortality of dolphins, however. Many purse seine nets have a so-called Medina panel of a denser mesh on the part of the net farthest from the boat. This mesh is more visible to the dolphins, enabling them to escape over it as the net is drawn in – sometimes with the assistance of divers.

A further hazard lies in the development of nets and lines. Constructed from synthetic materials, modern nets

are now incredibly strong and very durable. So not only do these nets pose a threat to cetaceans while in use – when abandoned they remain a danger to all marine life.

Cetaceans also suffer from human exploitation of fish stocks in other ways. Such is the efficiency with which we can harvest the oceans that many kinds of fish have been fished to the point of extinction. And those cetaceans that rely on these fish for food also suffer. Humpback whales, for example, were seriously affected by the overfishing of capelin, while the relatively recent but increasing exploitation of Antarctic krill could have a devastating effect on many species of baleen whale that are ill-adapted to exploit any other food source. And as if starving whales to death were not bad enough, some fishermen, anxious to preserve their dwindling fish stocks, will kill any perceived rival they encounter.

Studying wild cetaceans

In many ways it is highly exciting that even at the close of the 20th century there remains a number of species of large mammal about which little or nothing is known. Remarkable as it may seem there are some whales, such as Longman's and Andrews' beaked whales, that have never been seen alive, and it is highly likely that there are new species yet to be discovered. However, there are many obstacles to study. Despite the technological advances that have enabled humans to walk on the Moon, the oceans of planet Earth present a world that is almost equally difficult to explore. But progress is being made in the study of deep ocean cetaceans. And while

the underwater study of these species still presents huge problems, the surface identification of cetaceans using spotter planes and fast ocean-going research vessels has improved. Researchers have also become more adept at recognizing individual whales from their markings and a coordinated system using photographs – 'photo-ID' – is allowing different teams of researchers to combine data.

One of the questions most urgently in need of an answer is the population size of any particular cetacean species. This is of particular relevance to those species that have been extensively hunted. Species that migrate close to land, often in shallow water, such as the grey whale, can be counted visually. But for other species it is only possible to estimate the numbers based on extrapolation from the population observed. Another method of estimation involves marking the whales in some way and then recapturing them. These tags can only be recovered, however, after a whale has been killed. Mark recapture, as the technique is known, only provides an estimation of population size. It is a purely statistical technique in which a number of whales are 'marked' over a particular period and then, at a later date the numbers marked are compared with the frequency these whales are encountered.

Left and opposite: The valiant efforts of a few dedicated individuals to free whales, such as these humpbacks, trapped in nets can make little impact on the terrible mortality wrought by these 'walls of death'.

Although the keeping of cetaceans in captivity remains highly controversial, much of what is known about these enigmatic marine mammals has been learned from the study of captive animals.

Cetaceans in captivity

The sheer size of cetaceans prohibits most species being kept in captivity, and even among smaller species that can be confined in a tank, it has to be accepted that captivity is likely to modify their behaviour enormously. But from those species which have been confined – typically the bottlenose dolphin and the killer whale – a great deal has been learned.

Captive study has allowed scientists to observe aspects of social behaviour, measure sensory acuity, carry out physiological tests and understand something about the ways in which cetaceans swim. The majority of captive cetaceans, however, are kept in marine parks and dolphinaria, and although some marine parks combine scientific study with the exhibition of captive cetaceans for the entertainment of the public, most do not. Here the motivation is far more mercenary and the cetaceans' – usually dolphins – ability to learn and perform tricks on command is exploited solely for commercial gain.

The case against such commercial parks is a strong one. Unlike the majority of the animals currently kept in zoos, which have been bred in captivity, many captive cetaceans are wild-caught animals. The live capture of dolphins is fraught with problems. Many die from shock within a few weeks, and even those that do become accustomed to life in the confines of a pool die at a much earlier age than they would in the wild. There is also the moral issue of whether we should encourage wild animals to perform circus-like tricks for our amusement. The trainers of such animals would argue that the eagerness to learn and display their new-found skills is evidence enough that such performances are in no way cruel – but are they demeaning? Captive dolphins that flick balls into the air with their tails are actually replicating behaviour that has been observed in the wild where they perform similar feats with jellyfish. Perhaps the strongest argument in favour of the display of cetaceans is that it enables a large number of people to observe these remarkable animals closely and perhaps, as a result, care a little more about the fate of their wild relatives.

Whale watching

Observing free living cetaceans is another way in which people can get close to these marvellous mammals – but without any of the drawbacks, save cost, of marine parks. With the increased interest in cetaceans, 'whale watching' has become as popular as going on safari. In many parts of the world whales and dolphins come close enough to the shore to be visited by boat-borne tourists who may be able to feed or even touch these leviathans.

Occasionally it is not even necessary to leave the shore to observe, and even touch, these marine mammals. At Monkey Mia in Western Australia, for example, a school of bottlenose dolphins has essentially become tame, and individual dolphins will swim right into the surf, much to the delight of visiting tourists.

As with African safaris, however, the increasing popularity of whale watching has had negative effects. When the first whale watchers sailed out to view the pods of migrating grey whales off the coast of California, the whales appeared unconcerned and even allowed themselves to be touched. But constant harrying by the flotilla of tourist boats that now crowd these waters each year has taken its toll, and, as a result, the whales have begun to give the coast a wider birth on their travels – presumably to avoid such disturbance.

The future

Despite the current moratorium on commercial whaling, many species still face an uncertain future, further clouded by the increasing pollution of the world's oceans. Toothed whales, in particular, are particularly vulnerable: because tiny amounts of poison can pass through the food chain relatively harmlessly, it accumulates in top predators (like the toothed whales) with deadly effect.

On the positive side, the upswell in interest in whales and dolphins is being maintained. And with greater knowledge and understanding comes a greater ability to protect. Protecting these creatures presents many of the problems associated with conserving the larger terrestrial mammals: too large to be kept and bred in captivity, they need vast areas of unspoilt habitat if they are to thrive. So far, humanity's impact on the seven tenths of the Earth's surface covered by the oceans has been slight. It can only be hoped that before we cause the same irrevocable damage that has been wrought on land, we draw back to the ocean's edge and designate at least part of it a sanctuary. As the cradle of all life on Earth, such a gesture would be entirely appropriate.

As the twentieth century draws to a close, the future for the world's cetaceans remains a precarious one. But just as we have brought many of them perilously close to extinction, so too can we save them. All that is required is the will to adopt a more respectful attitude to these majestic mammals with which we share our blue world.

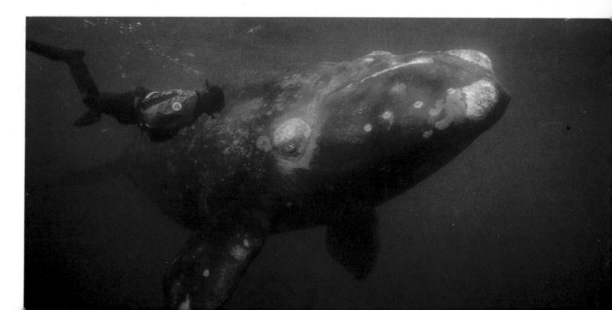

Index